TOULOUSE-LAUTREC

THE GREAT IMPRESSIONISTS

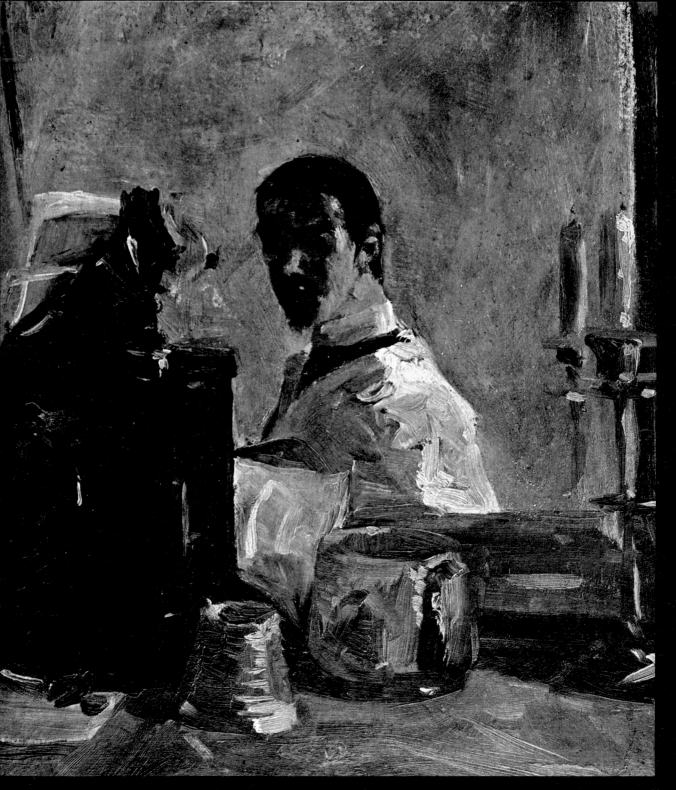

**Self-Portrait, 1880. Oil on cardboard, 15³/₄ × 12³/₄ in.
Albi, Musée Toulouse-Lautrec.**

TOULOUSE-LAUTREC

PHILIPPE HUISMAN - M. G. DORTU

THAMES AND HUDSON · LONDON

CONTENTS

SERIES DIRECTED BY DANIEL WILDENSTEIN
AND
REALIZED WITH THE COLLABORATION OF THE WILDENSTEIN FOUNDATION, PARIS

Photo credits: Wildenstein Archives, New York; Fratelli Fabbri Editori, Milan.

First published in United Kingdom 1973 by Thames and Hudson, London
Reprinted 1975

ISBN 0 500 86002 5

Printed in Italy

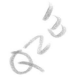

WHY I LOVE LAUTREC

by FEDERICO FELLINI

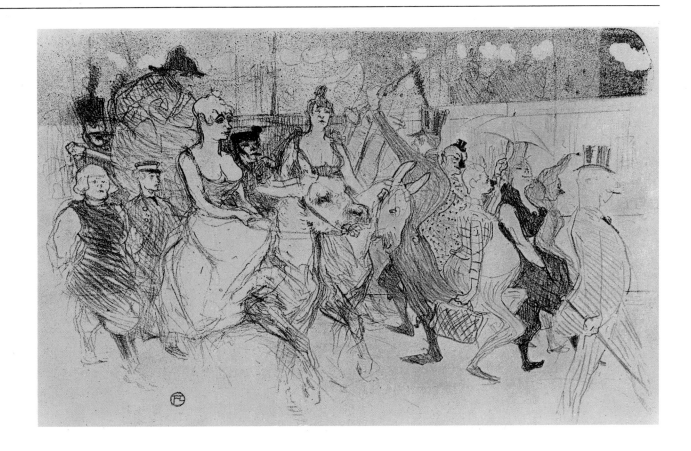

Gala at the Moulin Rouge, 1894. Lithograph, 11⁵/₈ × 18¹/₈ in. Albi, Musée Toulouse-Lautrec.

I have always thought of Lautrec as my brother and friend. Perhaps because Lautrec, before the Lumière brothers invented moving pictures, had devised intuitively the « frames » and the schematic approach of the cinematographer, but also probably because he was always attracted to social outcasts, to the destitute and the scorned, those whom the « respectable » people call depraved. It is hard to say precisely who inspired you throughout your career. But this I do know : I have never looked with indifference at a painting, a poster, or a lithograph by Lautrec, and thoughts of him have seldom been far from my mind. Here was an aristocrat who disliked high society, who believed that the finest and purest flowers sprouted in wasteland and rubbish heaps. He loved men and women, true women, those hardened and wounded by life. He despised painted dolls since, more than any other vice, he detested hypocrisy and artifice. He was simple and true, magnificent despite his physical ugliness. For this reason Lautrec lives on, thanks to his pictures, in the heart of each of us.

5

LAUTREC AT
THE VELODROME

by TRISTAN BERNARD

Michaël Bicycles, 1896. Poster, 47¼ × 34⅝ in.

A long, long time ago the writer of these lines held a high position at the Buffalo and the Seine velodromes in Paris. As the events manager of these two cycling tracks, he drew up the schedules and organized meets among prominent bicycle racers. The public

liked these matches. As regards their gate receipts, a race between Jacquelin and Edwards, for example, did better than a bigger field of starters in which Edwards and Jacquelin were pitted against Morin, Banker, Protin, and other stars of that day. You stand to gain by simplifying things. Good publicity agents will tell you the customer does not like complicated attractions. On the day of the race there was always some kind of a hitch: a delay in starting time, or one or two racers who would fail to appear in the handicap. So when the events manager appeared on the turf, ten thousand voices would shout, « Down with Bernard!! » That's fame for you.

Lautrec was an enthusiastic habitué of the velodrome. He'd come and pick me up on Sundays, then we'd lunch together and go on out to the Seine or to the Buffalo. I'd take him out onto the turf among the officials, but he'd usually wander away and sit down on the grass. I don't think he was very interested in who won the races. What excited him were the people and the colorful setting. He had expressions all his own to describe a man, and his words were as telling as his pencil. Of a well-known cyclist, he said: « So-and-so looks like a sole, with both eyes on the same side of his nose. »

One day we went out to Bécon-les-Bruyères to see a rugby match. Here again Lautrec was less interested in who won or how many goals were scored than he was fascinated by the shifting patterns of players and that strange animal—the huge wriggling centipede —which any scrimmage resembles. He couldn't take his eyes off a certain Scottish three-quarter back, this bull-necked giant with thick calves encased in red socks. At the sight of the man, Lautrec did not break into the classical similes which some academic would have come out with. Gazing with admiration at that rugged three-quarter back who was eyeing the ball with outspread arms, he said to me: « He looks like a man coming up from the wine cellar with a full stock of bottles. »

One might say of Lautrec what some writer—I don't remember whom—once said of another great painter: « His eyes are uniquely his own. »

L'Amour de l'Art, Paris, April 1931.

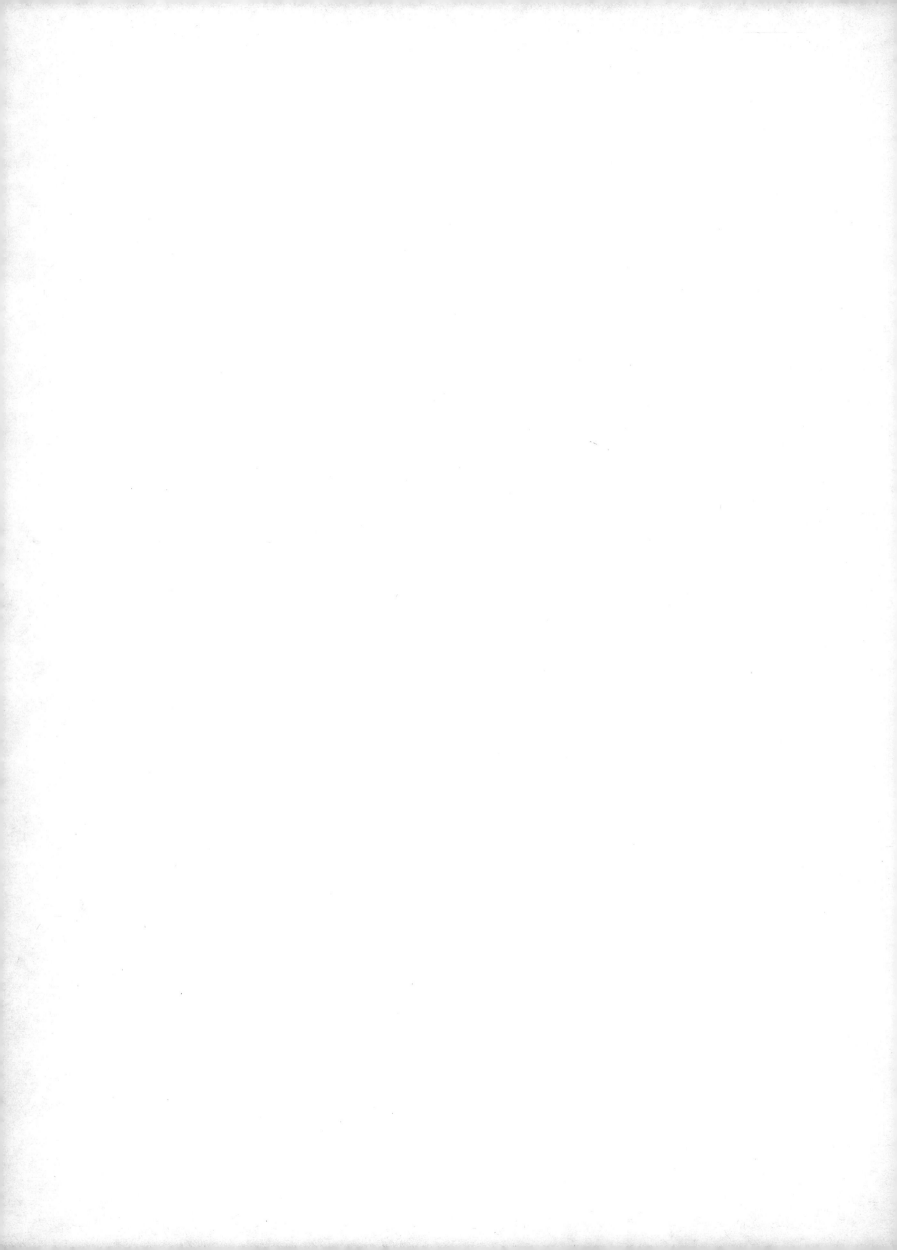

LIFE AND WORKS

1 - "BÉBÉ LOU POULIT"

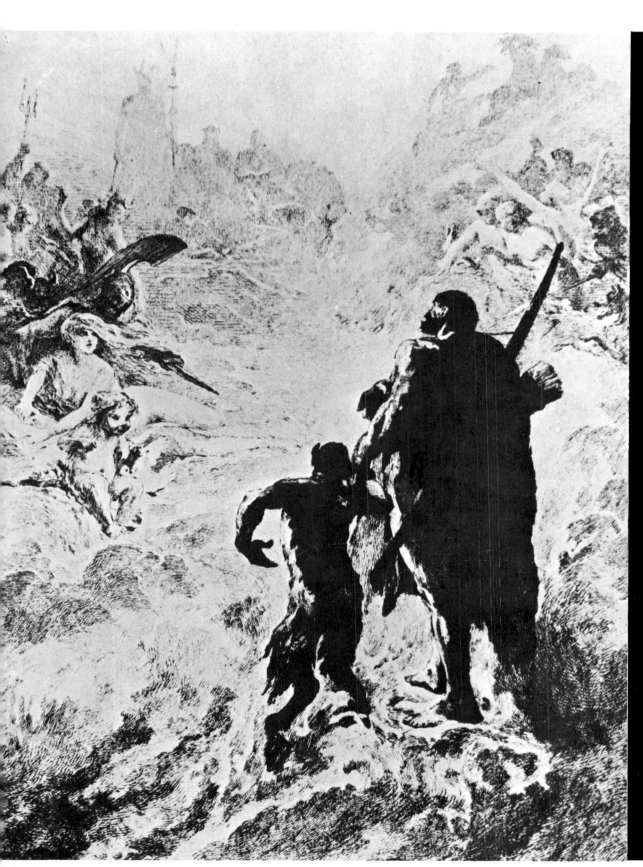

Illustration by Fernand Cormon
for the poem "The Satyr"
in third volume of Victor Hugo's
"La Légende des Siècles" 1884

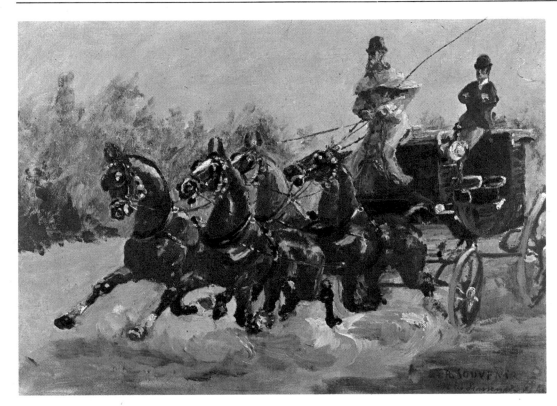

The stormy sky over the town of
Albi, in southwestern France, was
streaked with lightning on the eve-
ning of November 24, 1864. In one
of the oldest and wealthiest houses
in the medieval quarter, the Hôtel
du Bosc in Rue de l'École Mage, two
of the most illustrious and powerful
families in that region of France,
the Counts of Toulouse-Lautrec and
the Tapié de Céleyran family, were
awaiting the birth of the first child
of a new generation. The father,
Count Alphonse, had married his
cousin Adèle Tapié de Céleyran just
a year before; they had known each
other from childhood, and their
mothers—thus Henri de Toulouse-
Lautrec's two grandmothers—were
sisters. The baby born that night
was a fine, healthy child and was
christened Henri in honor of " King
Henry V " (better known as the
Comte de Chambord), the legitimist
pretender to the throne of France
since the forced abdication of his

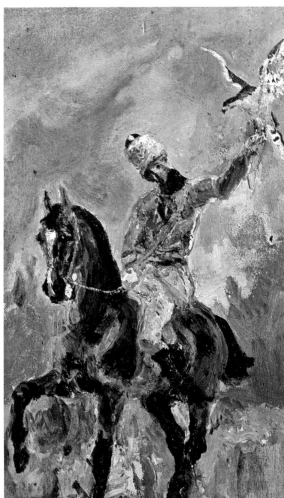

12

can manage to find me a light two-wheeler), and if there aren't any, a four-wheeler. ... I want some yellow and black harness and a dogcart. Now, remember ... a two-wheeler, if at all possible. Tell godmother to take charge of my order. Send your carriages as a model and also tell me what the landaus are like. "

And he signed this letter " Philéas Fogg, " after the hero of one of Jules Verne's most popular novels. No one in the Lautrec or Tapié families had to work for a living, but everyone kept himself occupied at some pursuit. Most members of the family were passionately fond of hunting, riding, painting, and fine cuisine and were quite adept at all of them. There was said to be a large chest in the household which a steward kept full of money and which everyone dipped into according to his needs. Count Alphonse was a sculptor of professional attainment—though he never tried to sell any of his work—and spent part of the year in Paris. He was also a keen student of the customs and mores of remote peoples. One day he returned to Albi disguised as a Kirghiz tribesman, and for a time even lived in a tent and adopted their exotic ways.

Henri drew, he went riding, wrote amusing letters, and learned English and Latin from his mother and private tutors. In 1872 he was sent to school in Paris, to the Lycée Condorcet, where one of his classmates was Maurice Joyant, who became a lifelong friend. By the age of ten, however, Lautrec had become a rather delicate boy. His parents then removed him from school in Paris and took him to a milder climate on the Riviera, where he made long stays in Nice.

As a boy Henri must have suffered from the widening breach between his mother and father, as the latter became more and more independent

grandfather King Charles X in 1830. Henri was an adorable child, charming and high-spirited. His parents doted upon him, and his abundant natural gifts were encouraged to develop freely. Within the family he was nicknamed " Bébé Lou Poulit," which in the Albi patois means " Pretty Baby " or " Little Jewel. " He was brought up among a host of younger cousins and childhood friends at the family châteaux of Céléyran and Le Bosc, where he spent a happy, carefree childhood. " Henri chirps from morning to night, " wrote one of his grandmothers. " He goes on like a cricket who brightens up the whole house.

His departure leaves an immense void behind each time, for he really takes the place of twenty people here. "

Little Henri was indulged and was spoiled not only by his parents but also by grandparents, uncles, and aunts, who gave him ponies and lavished toys upon him. At age ten, he wrote as follows to one of his cousins:

" Dear Raoul,

Augé said that he would get me a brougham and a dogcart ... now you tell me about a landau. Write and tell him plainly that if he doesn't get me these carriages, well then! I won't have any others (unless you

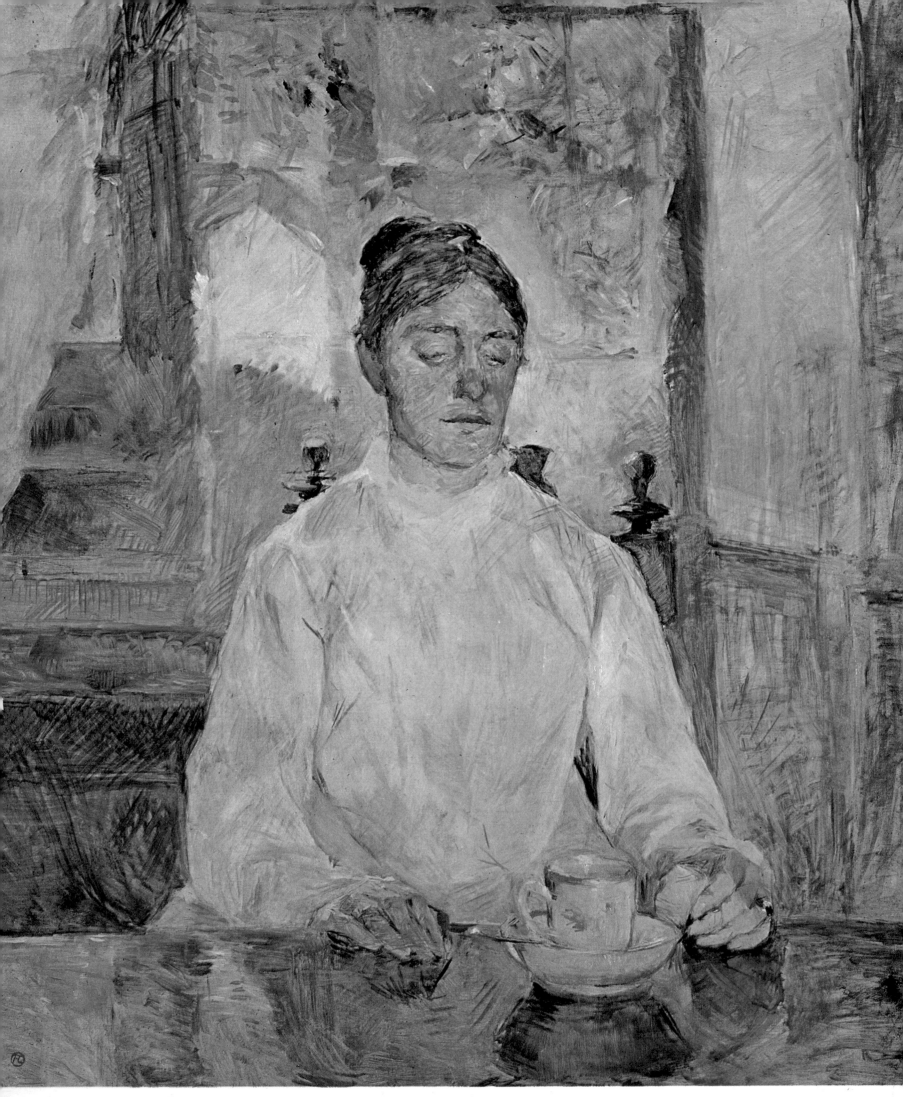

Countess Adèle de Toulouse-Lautrec Having Breakfast at Malromé, 1883.
Oil on canvas, 36³/₄ × 32 in.
Albi, Musée Toulouse-Lautrec.

1

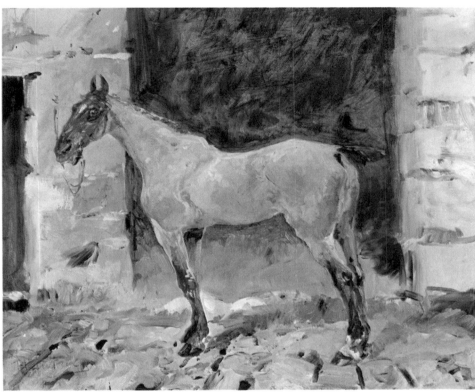

3

4

2

and eccentric in his ways. Yet he could still see the humorous side of things: " The Count, my father, " he once said, " never goes on a spree except with *café au lait!* " Though a delicate child, he lived a busy life both with sports and intellectual pastimes. " Henri does not seem to mind the humidity too much, " his grandmother informed the Countess Adèle, always an anxious and prudent mother. " The weather is so mild he can go out on good long rides with Urbain the groom. One hardly knows which is prouder, the teacher or the pupil. When he can't go outdoors, he spends his spare time drawing or painting in watercolors under the guidance of his uncle Charles. He is such an amiable boy that his good spirits keep up at the same pitch even when he's alone. He is still too young to go hunting with the gentlemen, though he is so plucky and adroit that he would not shrink from obstacles which are still too much for him. With such a jolly little fellow as that around, one could not help but shake off a black mood. "

But in 1878, when he was fourteen, Henri met with an accident which was to transform his life. He himself described this mishap in a letter to a friend:

" Dear Charles,

You will surely excuse me for not writing to you sooner when you hear the reason for my delay. I fell off a low chair onto the floor and broke my left thighbone. But now, thank god, it's on the mend and I'm beginning to walk with a crutch and someone to help me. I'm sending you the first watercolor I've done since getting out of bed. It's not so very good, but I hope you'll only consider that I meant it as a little keepsake. We don't know yet when we can go to Barèges. Granny and my cousins are going, but the doctor is afraid that the waters may do me harm. My uncle Raymond from Toulouse came to see me, but he couldn't give me any news of you. Good-bye, dear friend. My mother asks to be remembered to you and

The Painter Henri Rachou, c. 1882.
Canvas, 19³/₄ × 24 in. Dallas, Algur H. Meadows Collection.

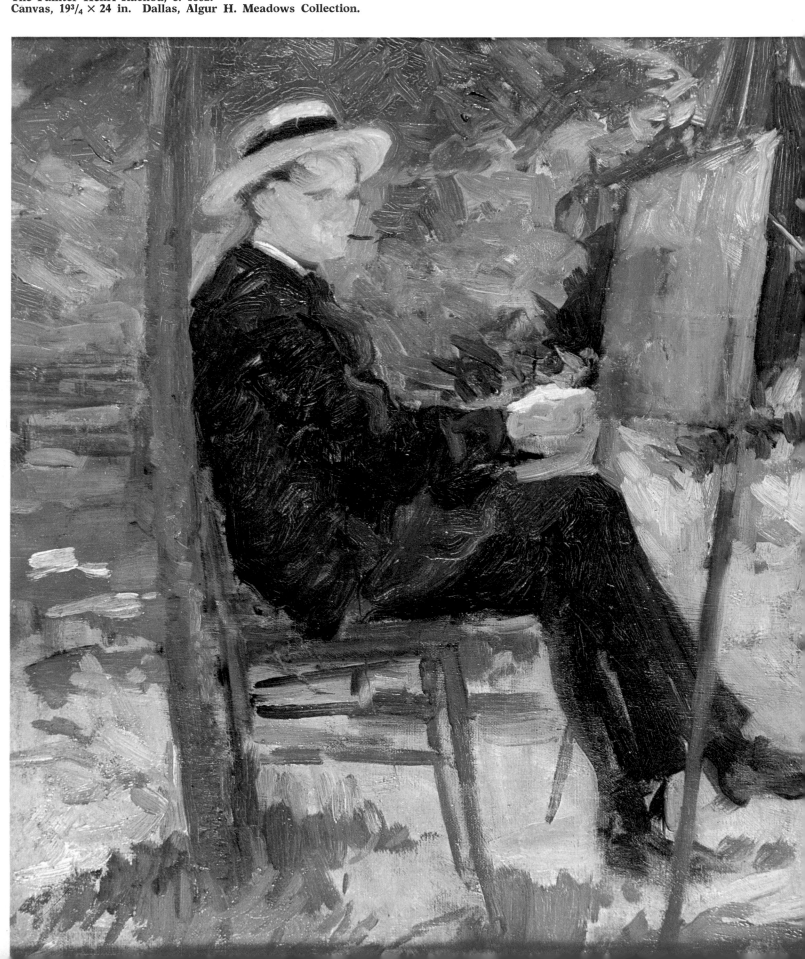

to your family. Please give my best regards to your mother and your sister.

Yours ever,

Henri de Toulouse-Lautrec. "

Unfortunately, this fracture had but barely healed when Henri met with another accident. " The second fracture, " wrote his father, " was due to a fall not much more severe, while out walking with his mother. He fell into a dry gully no more than four or five feet deep. While his mother went to find a doctor, the injured boy kept calm and, seated on the ground, held his thigh firmly in place with both hands flattened against it. " These accidents were in fact the consequence and symptom of a disease largely unrecognized then; it seems certain that Lautrec was suffering from polyepiphyseal dystrophy, or an underdevelopment of certain osseous tissues that left the bones abnormally brittle. The result was that Henri, though a boy of average stature before his two successive accidents, stopped growing afterward. At thirteen he was four feet eleven inches tall; as an adult he was still just about five feet tall—that is, not a dwarf, as he has sometimes wrongly been depicted, but a conspicuously short man. Moreover, while his head and torso were of normal adult size, his legs remained weak and stiff and abnormally stunted. It was this disproportion which gave his figure its curious aspect.

But Lautrec did not despair, and he could even laugh at his unfortunate lot. He wrote as follows to one of his friends: " On Monday the surgical crime was perpetrated, and the fracture—though so admirable from the surgeon's point of view (not from mine, of course)—saw the light of day. The doctor was in raptures and left me in peace until this morning, when, on the specious pretext of getting me to stand up, he had me bend my leg at right angles and made me suffer atrociously. Ah, were you here for only five short minutes a day! How serenely I could then look forward to my future sufferings! " When anyone pitied him, he would resort to jest: " Please don't cry so over me, I don't deserve it; it was very clumsy of me. ... I get ever so many visitors, I am terribly pampered. "

His family spared no expense in trying to find beneficial treatment for him, hoping always for a cure. So it was that he spent many long dull months in various spas. Though he took advantage of his situation to neglect his studies, he occupied his time avidly drawing and writing. In July 1881, when he was sixteen, he took his baccalaureate exam in Paris but failed. He then spent the rest of the summer studying intensively and took the examination again that fall. Writing to a friend, Lautrec announced the results lightheartedly:

" Caught up in the whirl of the baccalaureate, this time I passed. For my dictionaries and the right textbook, I neglected my friends, painting, and everything else worth doing in this world. Finally the examiners in Toulouse declared me acceptable, in spite of the nonsense I poured out in answering their questions! I quoted lines from Lucan that never existed; and the professor, wanting to look scholarly, swallowed it all whole. Well, that's all over now. ... You will find my prose pretty limp—the effect of the mental deflation following the strain of the exams. Let's hope for better things next time!

Your friend,

H. de Toulouse-Lautrec. "

In November 1881, he had his seventeenth birthday. He now obtained his parents' consent to study art seriously. His first teacher was René Princeteau, an artist friend of the

17

Lautrec family who specialized in paintings of horses. Henri enjoyed working in his studio and made such rapid progress that soon the pupil had nothing more to learn from his teacher. Princeteau then advised the Count and Countess to send their son to the atelier of one of the most celebrated painters in Paris at that time, Léon Bonnat, who also accepted some beginner students. A skillful but uninspired technician, Bonnat showed no understanding of Lautrec's genius. " You may be curious to hear what kind of encouragement I get from Bonnat, " wrote Lautrec to his Uncle Charles. " He tells me: 'Your painting is not bad; it's perhaps a bit too modish, but still it's not bad. But your drawing is truly atrocious.' So I'll just have

1

to buckle down and make a fresh start and plow on. ... "
Checking his own natural inclinations, Lautrec made a conscientious

effort to follow the advice of this academic painter. Then, after fifteen months of drudgery, he moved on to the art school of Fernand Cormon, a more genial but no less conventional master, who specialized in fantasy paintings of prehistoric life. Although Cormon was also an academic, and none too successful, Lautrec appreciated his professional skill as a draftsman and was happy to collaborate with him anonymously on some illustrations for Victor Hugo's epic *La Légende des Siècles*. It was undoubtedly Lautrec who designed the plate illustrating the poem " The Satyr, " in which Hugo evoked the mysterious spell of all true poets, perhaps too that of the young painter who considered himself the ugliest man in the world: " None knew this rascal's name. / He had the shameless innocence of Rhea. / Hercules went and fetched him from his den. / To him Apollo said: 'Desirest thou the lyre?' — 'I do.' / He stood enraptured in the spell of dreams / And spirit-stirring dawns and firmaments. / Such glowing depths within his eyes she saw / That Venus of his beauty stood in awe. "
Though Lautrec could not work up any enthusiasm over his teacher's painting style, at Cormon's he did meet up with Anquetin, Menz, and Rachou. Together they would spend the evening at the Mirliton, Aristide Bruant's little cabaret, where they joined lustily in a chorus written by Bruant: " At the Bastille / We love to see Dogskin Nini: / She's sweet as a girl can be! / So we love to see Dogskin Nini / At the Bastille. " And strange as it may seem, Lautrec felt equally at home in Cormon's

studio and Bruant's café-concert, for in both places he found that free-and-easy atmosphere of comradeship he loved.
Among his fellow students were a number whose innovations later proved decisive and whose work and personality appealed to him. Émile Bernard was there, already preaching artistic revolution. He soon left to join Gauguin in Brittany where, as both an inventive painter and a brilliant theorist, he helped to found the Pont-Aven group; then, in transmitting his message to the future Nabis, he was to exert influence on Bonnard, Vuillard, and above all Sérusier. At Cormon's studio Lautrec also met Vincent van Gogh, a moody and quiet, unsmiling Dutchman who had arrived in Paris in February 1886 and kept very much to himself. Lautrec admired his work and his idealism and became friendly with him. This was a curious friendship. Both of them were men of passionate feeling, equally in love with life and yet equally frustrated; one of them, however, always saw the humorous side of things, the ironies of fate, whereas the other brooded continuously over the tragedy of life. Lautrec did a pastel portrait of Van Gogh that is arresting in its intense expression and truthfulness. Two years later, when Van Gogh tired of Paris and yearned for the countryside again, Lautrec advised him to go to the south of France, where he himself had spent his childhood. After that they saw each other only once more, when Van Gogh passed through Paris just two weeks before committing suicide, in July 1890, in the little village of Auvers-sur-Oise.

1 **"Voilà ce que nous avons eu et ce que nous avons"** (Here Is What We Had and What We Have): sketch on a letter by Lautrec, c. 1881. Private collection.
2 **Girl with Red Hair, 1889. Canvas, 21⁷/₈ × 19³/₄ in. Private collection.**

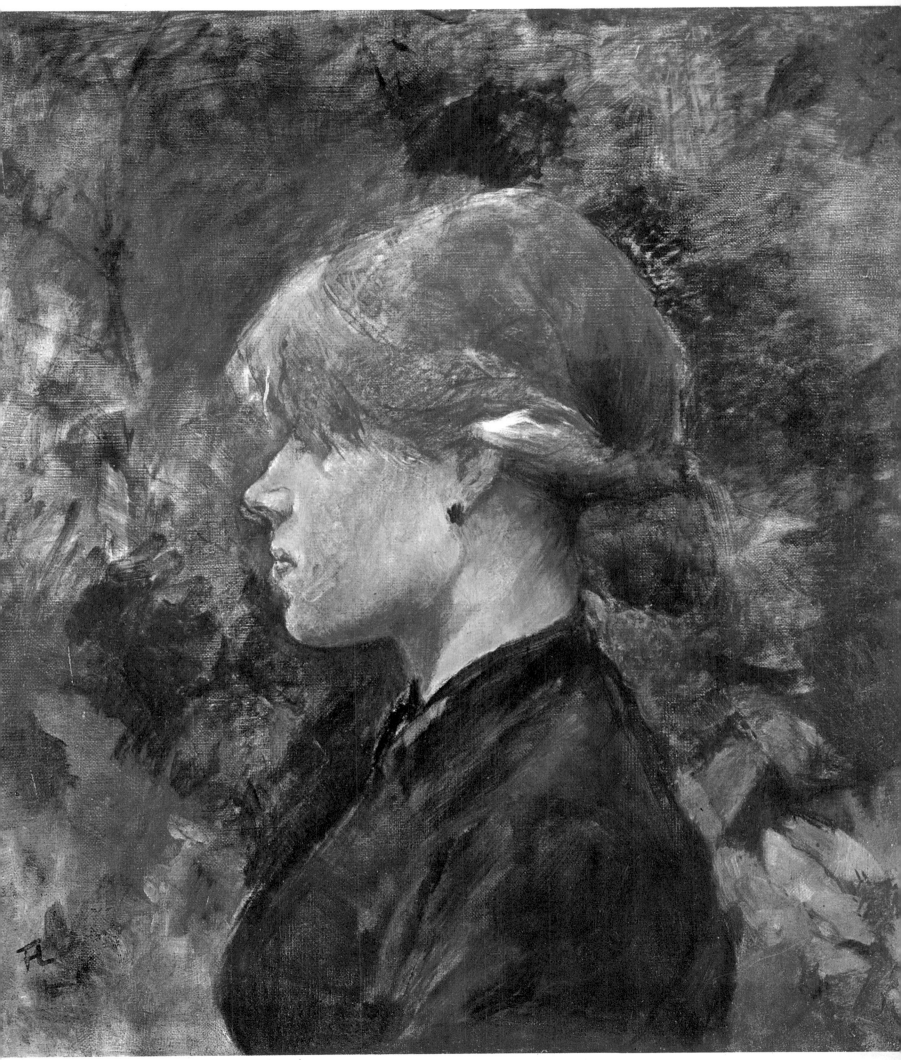

2 - PARIS BY NIGHT

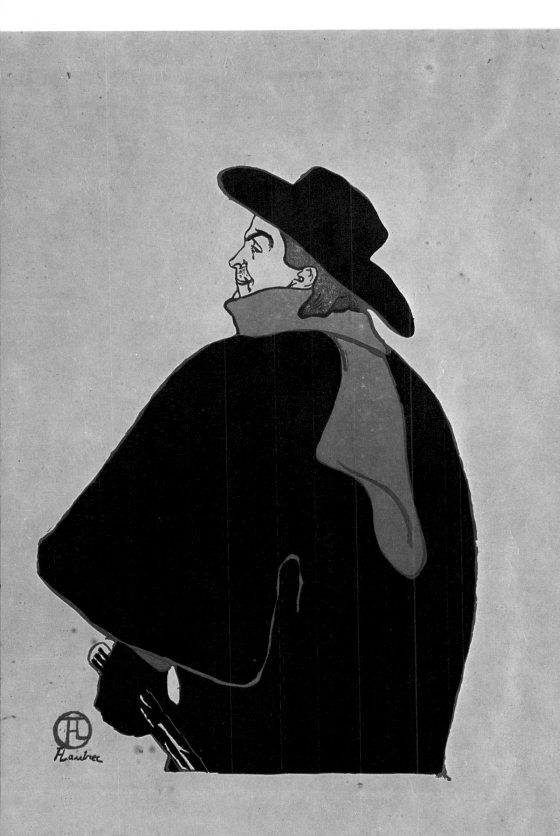

Aristide Bruant in His Cabaret, 1893.
Poster, 50 × 36¹/₄ in.

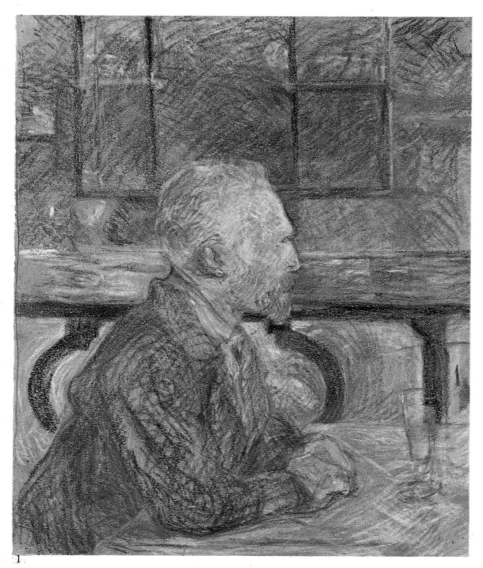

1

"You pack of abortions and half-baked fools! / Where do you come from? / Have your mothers no bubs, and your fathers no tools? / You must've been suckled on asses' milk, / That's why you're still in the rough. / Here we'll have none of that ilk, / Let parents finish the job and show their stuff! "

With such songs and taunts as this, Aristide Bruant welcomed bourgeois customers to his tiny cabaret " Le Mirliton " in the Boulevard Rochechouart, where they were charged high prices for watery beer and the privilege of hearing him sing senti-mental or insulting and anarchistic songs in a loud voice. Lautrec and his friends were delighted with Bruant's rebellious spirit. When he wrote a series of witty and tender songs evoking each of the quarters of Paris, Lautrec decorated his cabaret with some pictures of women of the streets, ostensibly illustrating Bruant's lyrics. Nini-peau-de-chien (" Dogskin Nini "), for instance, was the heroine of Bruant's song on the Bastille district; the model for her in Lautrec's picture was Jeanne, the wholesome girlfriend of the painter Frédéric Menz, a fellow student at

Cormon's whose well-to-do parents were the first to buy paintings by Lautrec.

The young painters at Cormon's studio led a gay, carefree life. Their ringleader was René Grenier, not only because of his undisputed social gifts but also because of his independent income and his charming wife Lily, a tall, handsome and loquacious redhead who was a former model. Lautrec fell under her spell, painted her portrait, and for several months actually lived in the apartment of this friendly couple. To all of their circle, painting, drawing and illustrating would seem a necessary extension of their constant whirl of amusements and worldly distractions. Art and daily life went hand in hand. One of the favorite pastimes of Lautrec, Grenier, and their friends was decking themselves out in extravagant costumes. And since they were keen admirers of Japanese prints, they were especially fond of donning Oriental costume. But their fun was not complete till they had taken photographs or painted pictures of themselves.

When this merry group of friends went off to enjoy a few days in the country at Villiers-sur-Morin, Lautrec could not resist the pleasure of painting the walls of the inn where they were all staying. And since he always yearned to be back in Paris as soon as he left it, he chose to depict the Parisian theaters, cabarets, dance halls, and circus rings—all the places where he felt truly at home.

The fact that he was continuously drawing (and, very often, subjects prompted by the circumstances of the moment), regularly decorating invitations, menus, and varied publicity pieces (the greater part now lost), and earnestly seeking commissions for illustrations even in popular papers and magazines, all this

1 Vincent van Gogh, 1887. Pastel on cardboard, 21⅝ × 18½ in. Amsterdam, Collection Vincent van Gogh Foundation.
2 Photograph of Carmen Gaudin, Lautrec's model for "The Laundress."
3 The Laundress, 1889. Canvas, 36⅝ × 29½ in. Paris, Private collection.

shows that Lautrec did not consider art to be the special preserve of only a privileged few. Rather, for him, it was an outgrowth of the simplest acts of everyday life. Nor was he ever wholly at ease in painting professional models. He liked to be genuinely captivated by a subject, and then his inspiration flowed freely. " One day when Rachou and Lautrec were on their way to lunch at Boivin's, " wrote the painter François

2

Gauzi, " they passed a young woman dressed simply, like a factory girl, but with auburn hair that made Lautrec stop and exclaim with enthusiasm: 'Isn't she fantastic! And how ripe she looks! If only I could get her to pose for me, that would be wonderful! You must ask her.' 'That's easy,' answered Rachou, who went after the girl at once. "

" After listening to the painter's polite request, the girl hesitated and said she had never posed before. But Rachou persisted and overcame her apprehension. Her name was Carmen Gaudin. She was a sweet-tempered working-girl, a little on

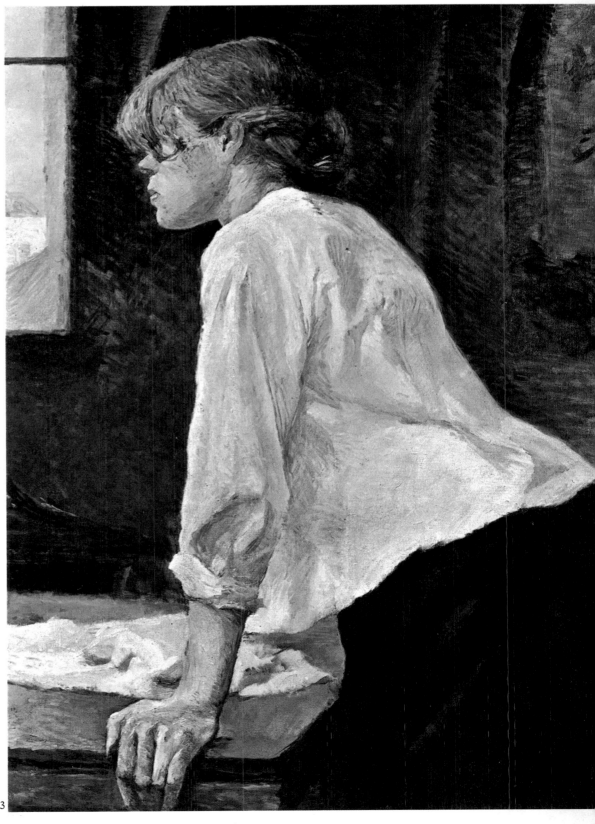

3

1, 2 **Photographs of Hélène Vary.**

3 **Portrait of Hélène Vary, 1888. Cardboard, 29 × 19³/₄ in. Bremen, Kunsthalle.**

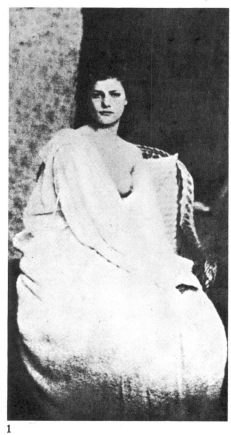

1

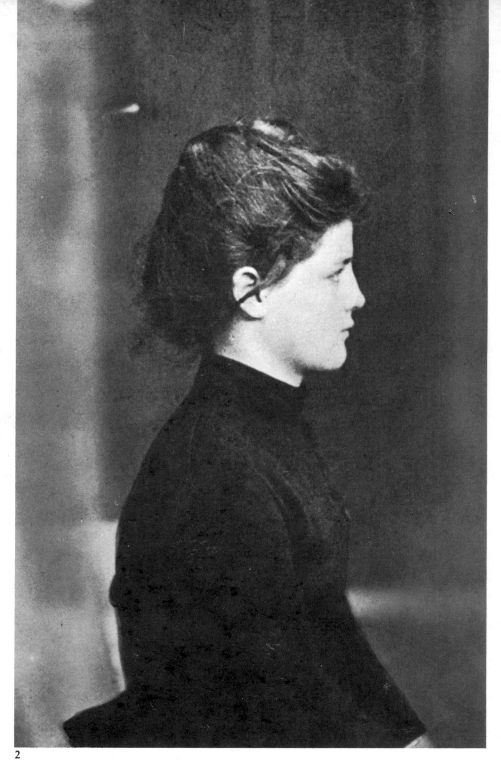

2

the puny side. Lautrec, who had imagined her to be a formidable bitch, was very surprised when he learned that her lover beat her to a pulp. She was punctual and for a long time remained his favorite model. "

Under Lautrec's brush, Carmen became a superb *Laundress*. And then, as he was still illustrating Bruant's songs about Paris, he portrayed her as Rosa la Rouge, heroine of the song " At Montrouge. " He was on the friendliest terms with Bruant. Through him and his cabaret, Lautrec felt he had the best chance of winning a truly popular audience, a public that interested him more than those middle-class collectors on whom most artists then depended for a living. Lautrec thus came to prefer newspaper illustrations and poster ads to easel painting, for

these enabled him to reach the widest possible public. He contributed to *Le Courrier Français* and *Paris Illustré*. The latter was edited by his old schoolmate Maurice Joyant, who also managed a print and picture shop and was as keenly interested as Lautrec in painting and in typographical problems. Together the two experimented with printing techniques; brush in hand, Lautrec worked out strikingly simplified schemes for his illustrations, in pictures that were for him visual exercises carried out with other purposes in mind, namely, as rough drafts for more ambitious, finished paintings.

The Mirliton was not, of course, the only cabaret Lautrec frequented. He also liked the Chat Noir, a unique music hall managed with a firm hand by Rodolphe Salis and starring

such popular singers and also songwriters as Maurice Donnay, who became a literary celebrity, and Xanrof and Goudeau, two all-but-forgotten names whose songs are still popular in France after nearly a century. Then, too, Lautrec could often be seen at the Moulin de la Galette, a dance hall atop Montmartre which, since the days Renoir had painted it, had gradually lost its countrified simplicity and was becoming the haunt of pimps and prostitutes. It was now also a place where ambitious young women displayed their talents as dancers and variety performers. There, for the first time Lautrec saw " La Goulue, " a young dancer with a brilliant but all-too-brief career before her.

On October 5, 1889, at 90 Boulevard de Clichy, on the borderline between Montmartre and Paris proper, M.

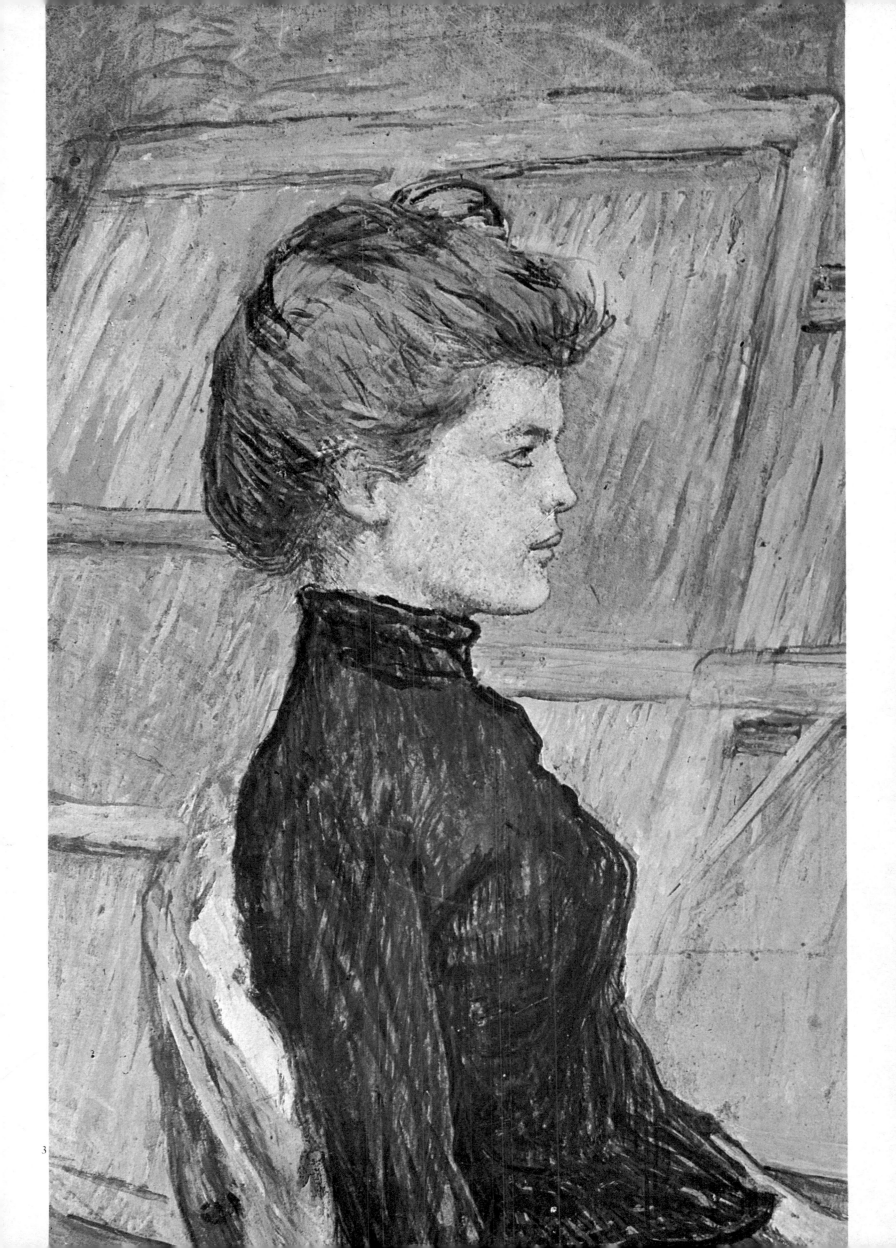

Sketches of legs.

Charles Zidler opened his luxurious entertainment palace with a huge dummy windmill towering over the entrance—the famed Moulin Rouge. Covering a vast area, it consisted of a series of fair booths, each offering a novel attraction, such as a huge wooden elephant whose sides folded down to form a stage on which some "Moorish" dancing girls did a turn. There was also a garden in which monkeys roamed about freely. But the heart of the place was a huge raised ballroom decorated with colorful hangings, all the gaudier in the lurid glare of gas lamps. The shows were lively and varied, not the least of the attractions being the motley crowd of seated and standing spectators. An orchestra with plenty of brass set up a deafening roar to announce the singers and acrobats, like the famous "Pétomane" who grunted out classical tunes from his backside, and above all the succession of dancing girls who kicked up long-skirted legs to reveal their bare and shapely thighs.

Having already done some fine pictures of La Goulue, Lautrec was asked to design a new poster for the Moulin Rouge. He was barely twenty-six and had not yet ventured into this exacting medium. Breaking away from the style of Willette, who was then the leading poster designer, and highly successful because of his knack of choosing agreeable subjects, Lautrec at once hit upon one of the secrets of successful modern advertising art—bold, arresting simplification. Right in the center of the composition he pictured the delightful, blond La Goulue in profile, wearing a red blouse and a white skirt. She alone was the subject of this striking poster, but was set off by the gaunt figure of her dancing partner Valentin le Désossé ("the Double-Jointed"), seen backlighted

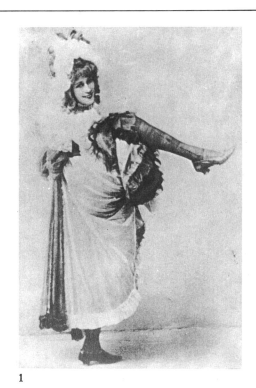

1

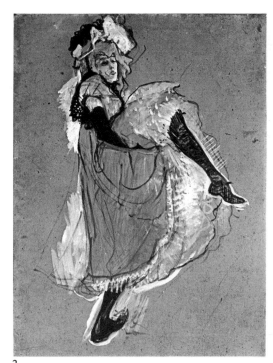

2

in the foreground. Behind them loom the shadowy figures of spectators, and at the top are the words "Moulin Rouge," which are repeated three times in eye-catching letters. Both the poster and the dancer were a tremendous success, for instantly Paris discovered, with the same enthusiasm, the breathtaking originality of both artists: La Goulue's captivating spontaneity and Lautrec's daring graphic genius. From now on the youthful Lautrec was in great demand as a poster designer. His old friend Bruant was naturally anxious to be portrayed by him, and in 1892, when Bruant was starring in the show at Les Ambassadeurs, a snobbish and expensive café-concert in the Champs-Elysées, Lautrec did a poster for him. The manager Ducare sternly disapproved of the result: "Take that thing down, ... that, that trash! It's awful!"

"Ah, my dear man," replied Bruant, "you are going to leave that poster as it is—and what's more, I want it stuck up on both sides of your stage! And, you hear now, if it's not there by quarter to eight—not eight o'clock—I won't go on! I'll pack up and leave! So, have you got that straight?"

"At the stated hour," writes Joyant, "the poster was displayed onstage, framing Bruant. Both the singer and his poster had an enormous success. After the show Ducare admitted he had been wrong."

"Well," said Bruant condescendingly, "as punishment, dear man, you are going to see that the walls of Paris are covered with this poster." From then on, Lautrec made many pictures and posters of music-hall stars. One of them, Jane Avril, was actually launched by Lautrec, who discovered her working as a chorus girl at the Moulin Rouge. She was very slim and agile, had a creamy white complexion, and danced solo numbers in a refined and decorous style. "She danced," as Joyant said,

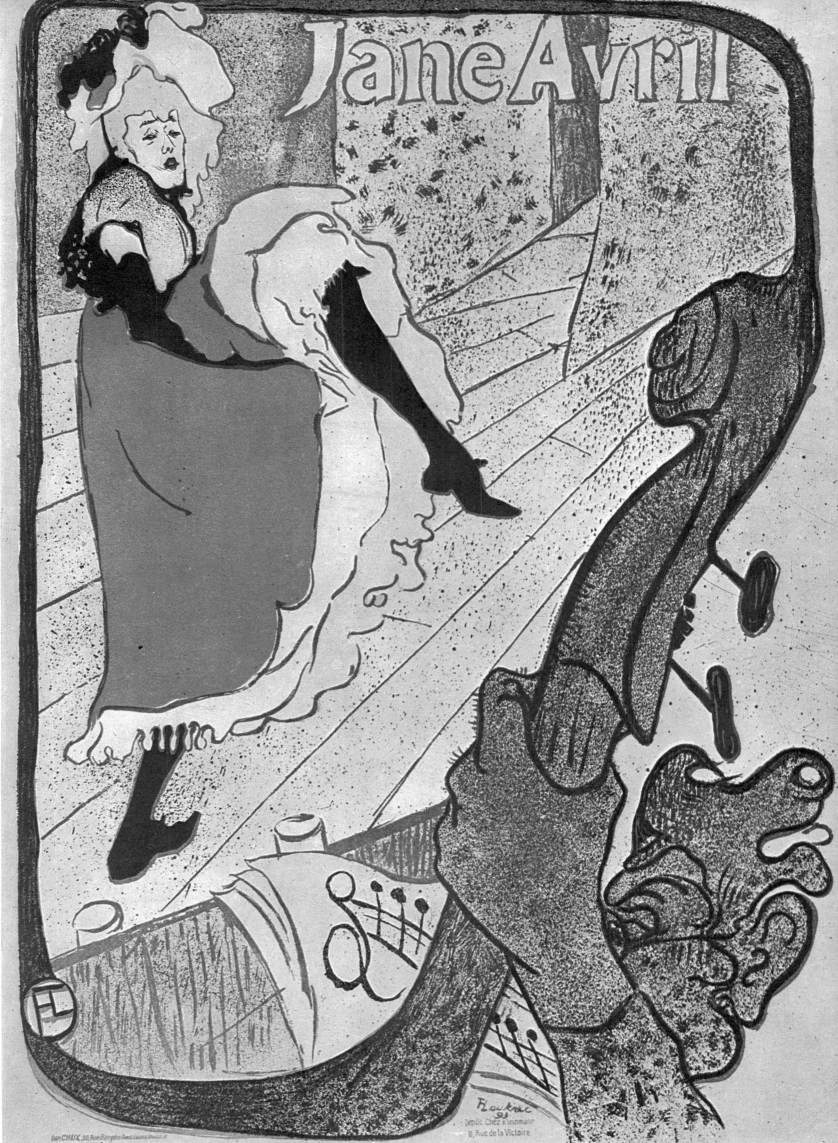

"like an orchid in ecstasy." Lautrec portrayed her in a poster for a music hall called the Divan Japonais; then he did a much larger one for her reappearance at the Jardin de Paris, and later designed a poster for a show she gave in London but without much success. She figures repeatedly in Lautrec's pictures, his lithographs, and posters.

May Belfort was not so pretty, but her odd style of singing and dress caught Lautrec's eye. An Irish girl, she would come onstage in little-girl frocks, fondling a black kitten and singing English songs in babyish accents: "I've got a little cat, / I'm very fond of that." These inanities amused Lautrec, and for her show at the Petit Casino he designed an all-red poster which proved a great success. Through May Belfort he met another Irish singer, May Milton, whose face was so ugly that Lautrec's friends were frightened of it. But, undeterred, he took it into his head to launch Miss Milton and designed a fine blue poster for her. Though it failed to win over any of the music-hall managers, the poster has ensured her posthumous fame.

Lautrec's name is now inseparably tied with that of Yvette Guilbert. They saw each other a great deal and admired each other's talents, but the memorable poster that should have been the logical result of their mutual esteem was never done. A gifted singer, monologist, and actress, Madame Guilbert was by far the most popular of all the Parisian music-hall performers in the 1890s. Lautrec was dying to meet her, and he was finally introduced by Maurice Donnay, her songwriter. Awed by her presence, for once Lautrec could not find his tongue and at first disappointed the famous star. But he proposed to do a poster for her, and she agreed to look at his designs.

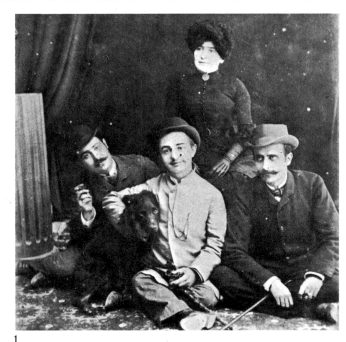

1

2

"Sir,
I should be very happy to see your posters. I shall be at home on Thursday at 7:30 P.M., or Saturday at 2. Thank you. Yvette Guilbert."
Later she wrote again:
"Dear Sir,
As I told you, my poster for this winter is ordered and is nearly finished. So we'll have to put it off till another time. But for heaven's sake, don't make me so dreadfully ugly!

A little less, sir, if you please! ... Many people who come to see me shriek with horror at the sight of the colored sketch. ... Not everyone can see the artistic side of it ... oh, well!! With grateful thanks,
Yvette."
Though she refused the poster, Mme. Guilbert did later acknowledge Lautrec's illustrations for two picture albums dedicated to her, with a text by the critic Gustave Geffroy:

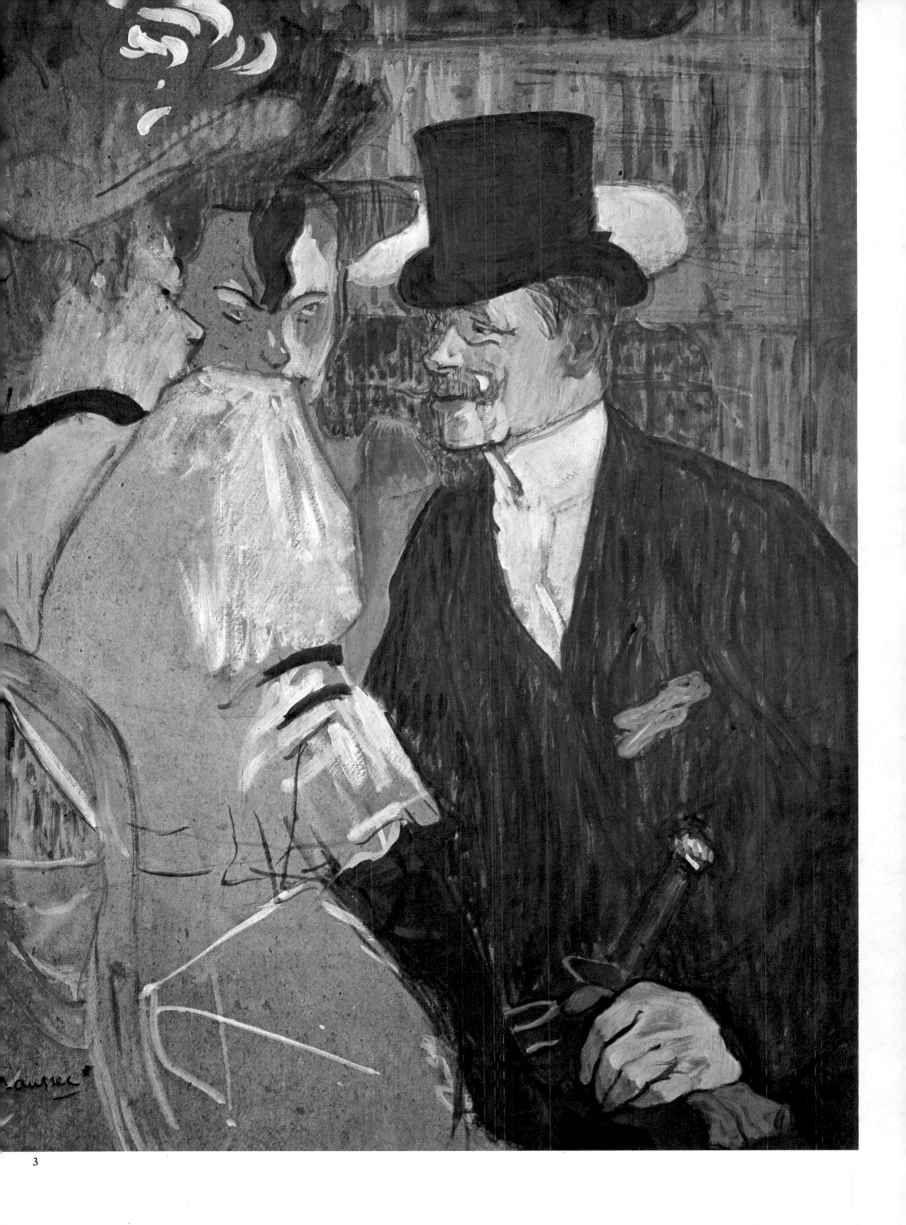

3

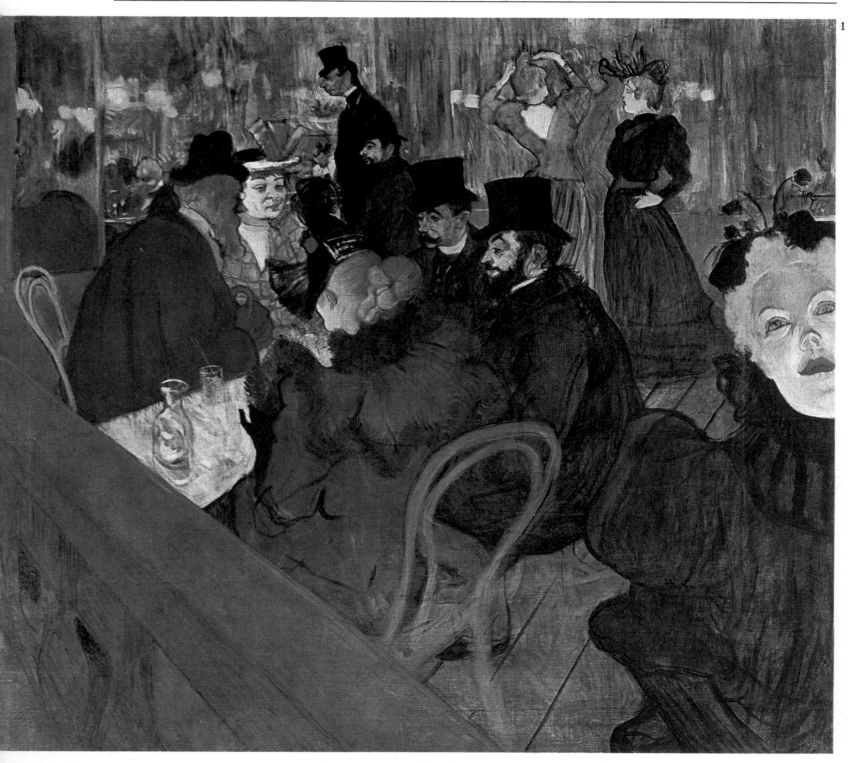

1 At the Moulin Rouge, 1892. Oil on canvas, $48^5/_8 \times 55^1/_2$ in.
Chicago, Courtesy of The Art Institute of Chicago.

2 At the Moulin Rouge (detail).

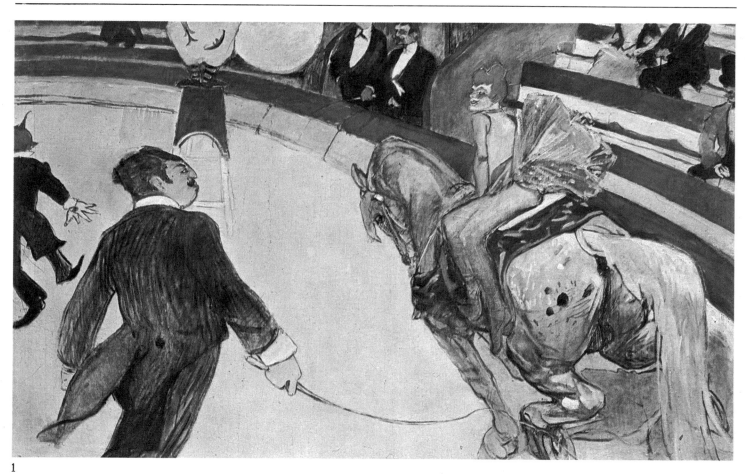

1

" Dear Friend,
Thank you for the nice drawings for Geffroy's book. I am so pleased! so pleased! And will always be grateful to you, believe me. Are you now in Paris? If so, do come for lunch one day next week at my new home, 79 Avenue de Villiers.
With best regards, thanks again.
Yvette. "
He later designed a ceramic tile (the only one he ever made) with a likeness of Yvette: " Little monster! " she wrote on the fresh clay. " What a horror you've made! " Lautrec, who never ceased to admire her, once remarked to Joyant as they were boating together: " I was lucky enough to be taken in tow by a star. "
The most bizarre and mysterious of Lautrec's heroines was indubitably Loïe Fuller. A copper-haired young woman from Illinois, she took the Paris music halls by storm with a highly original style of dancing, a solo act in which she made use of electric spotlights, then a great novelty in Paris, to cast changing color hues over her filmy gowns, which she whirled round her with long rods. Even poets and professors came to watch her performances. To capture the effect of her novel dance, Lautrec devised a new lithographic technique, coloring the print by hand and spattering it with gold dust—creating a strange image in which the stage can be glimpsed among the shadows, with vague indications of the dancer's head and legs. But most prominent of all are her voluminous veils, seen as if floating in a mist of iridescent colors.
Though busy with posters, lithographs, and his intense nightlife, Lautrec still found time for painting. He had drifted away from Cormon's studio and after 1889 saw little of his old teacher, whose artistic orientation and technique were increasingly remote from his own. But he exhibited his paintings at Bruant's cabaret Le Mirliton, at the Tambourin with Van Gogh, and even at a clubroom with a strictly bourgeois membership (the Cercle Volney), as well as in Belgium on several occasions. Thus, it was certainly not his own fault that he went so long unrecognized as a serious painter and was instead considered mainly as a poster designer and illustrator.

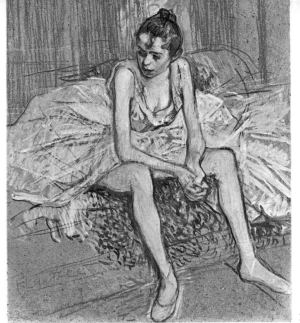

2

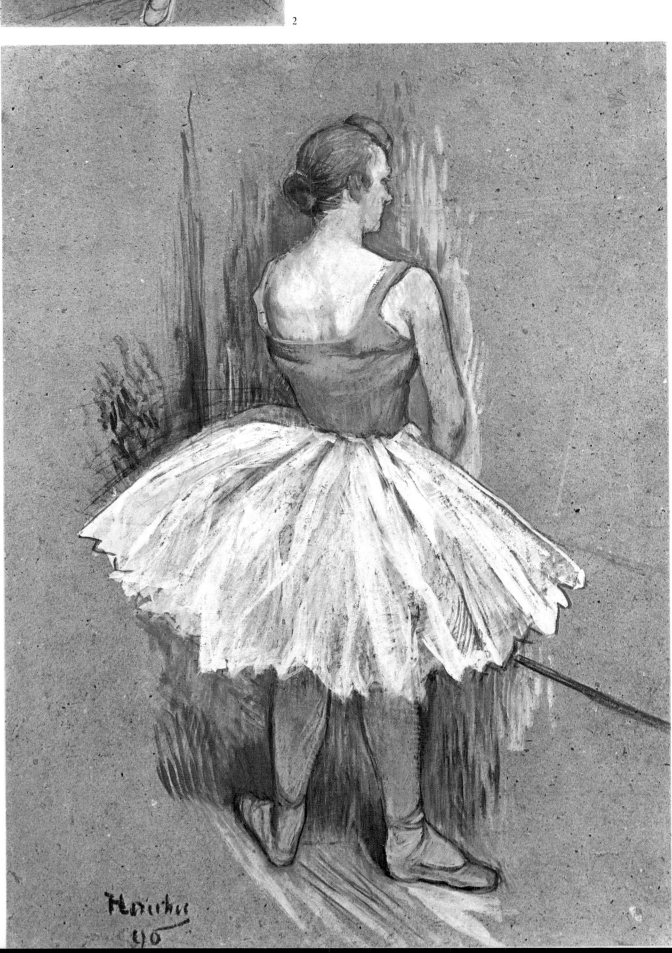

3

3 - THE "HOUSES"

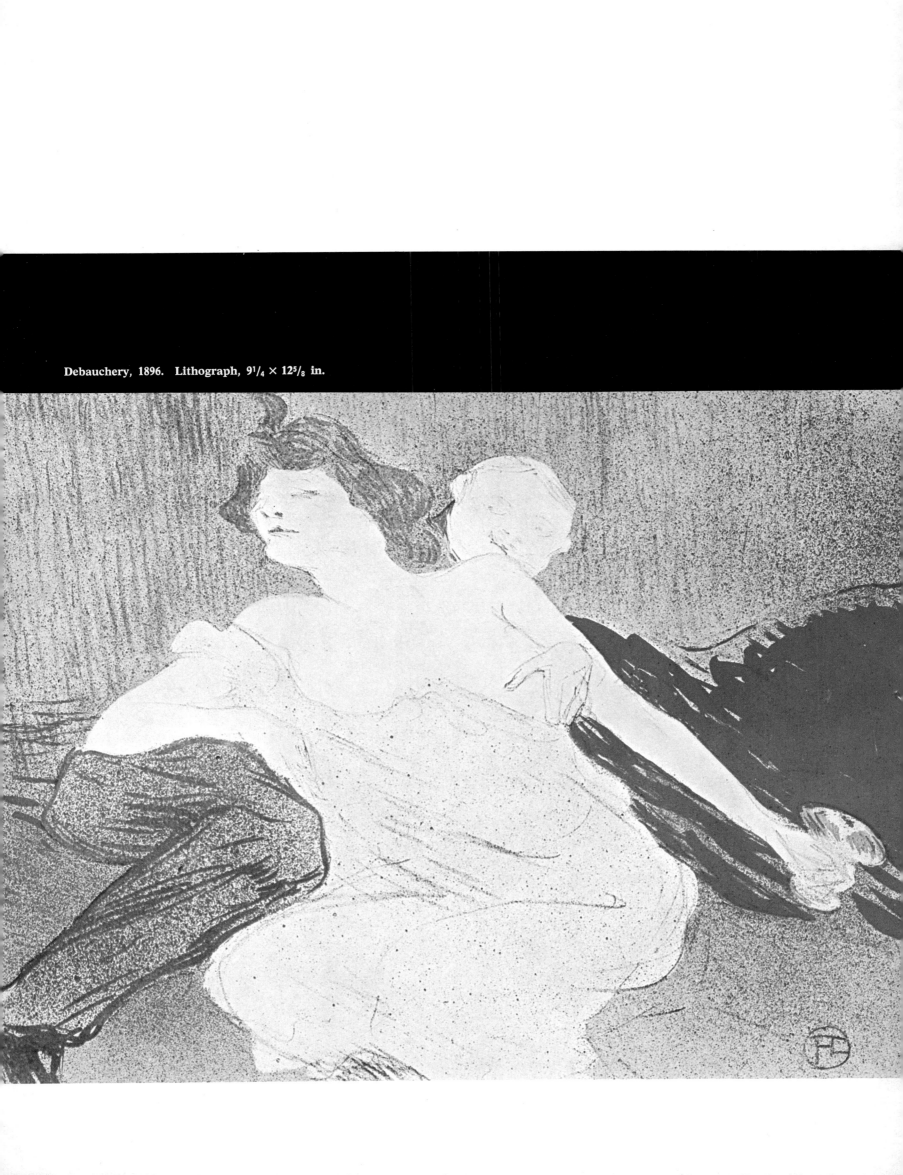

Debauchery, 1896. Lithograph, 9¼ × 12⅝ in.

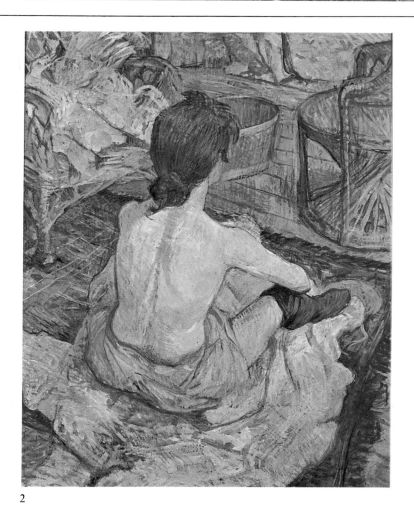

1

" It is one of those wonderful privileges of art that the horrible, when artistically expressed, and pain if stylized and patterned fill the mind with quiet joy. " Lautrec would almost certainly have agreed with that remark by Charles Baudelaire, the great nineteenth-century French poet and critic, because for him also the horrible had a beauty of its own and pleasure and suffering often intermingled. The society in which Lautrec lived was not at all like our own, though it shared with an untroubled conscience many of the defects of the contemporary world. France in Lautrec's day was a republic, and Christianity was the religion professed by most Frenchmen; but social barriers were very much stronger than those of today, and the bourgeoisie, by then triumphant for a century, had accepted that triumph as its just due. It ignored the squalor of working-class life and the hypocrisy of a moral code which overlooked adultery and condoned the legalized houses of prostitution where the daughters of the poor were offered for the pleasure of the rich—and yet, ironically, which ostracized any man of good birth who married a woman of lower social standing.

Precisely because he was an aristocrat by birth, perhaps, the scion of one of the oldest families in France, Toulouse-Lautrec saw no real difference—socially speaking—between a streetwalker and nouveaux riches. Thoroughly conscious of the tremendous hypocrisy of the world in which he lived, Henri himself judged individuals on their own merits, as human beings. For him aristocracy was a matter neither of money nor of birth—it was a gift. So he recognized this quality even in so-called " fallen " women while, on the contrary, stressing the grotesque, often despicable affectations of most so-

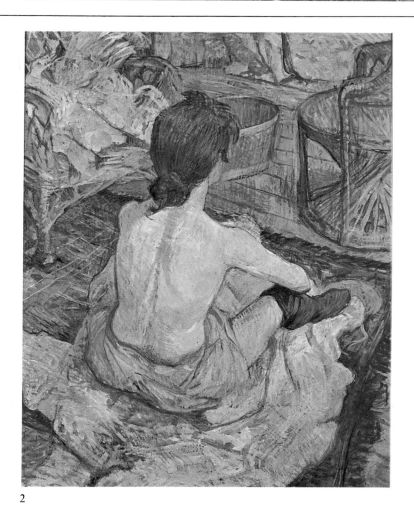

2

ciety people, the *beau monde*.
If Lautrec felt so much at home in Montmartre, the reason was perhaps that he liked to live in an equivocal situation, as if on the borderline between two worlds. He was deeply attached to his mother, who had moved into a very bourgeois apartment in Rue Victor Massé, not far from her son's studio. Both were near the outer edge of Paris that was marked by the large cemetery of Montmartre. But the Countess de Toulouse-Lautrec was slightly within the city limits, while Henri was located just beyond them, at the corner of Rue Caulaincourt and Rue Tourlaque in a house that still stands there. The artist often went to his mother's for lunch and took along any friends for whom she had

shown a liking. He felt comfortable in her quiet, tidy apartment, with its pleasant smell of lavender and beeswax polish. Paul Leclercq, who often went with him, was one time amused to see Lautrec pull a small, highly seasoned sausage out of his pocket and pass it round among the guests at table: that was his way of adding a little " spice " to the family meals.

His letters to his mother are those of a loving, very prudent son:
" My dear Maman,
I am sorry to hear that you have not been feeling well. This wind really brings no good to anybody. Uncle Odon has kept to his room for three days, but he has been cured thanks to a strong purge. I myself took some castor oil yester-

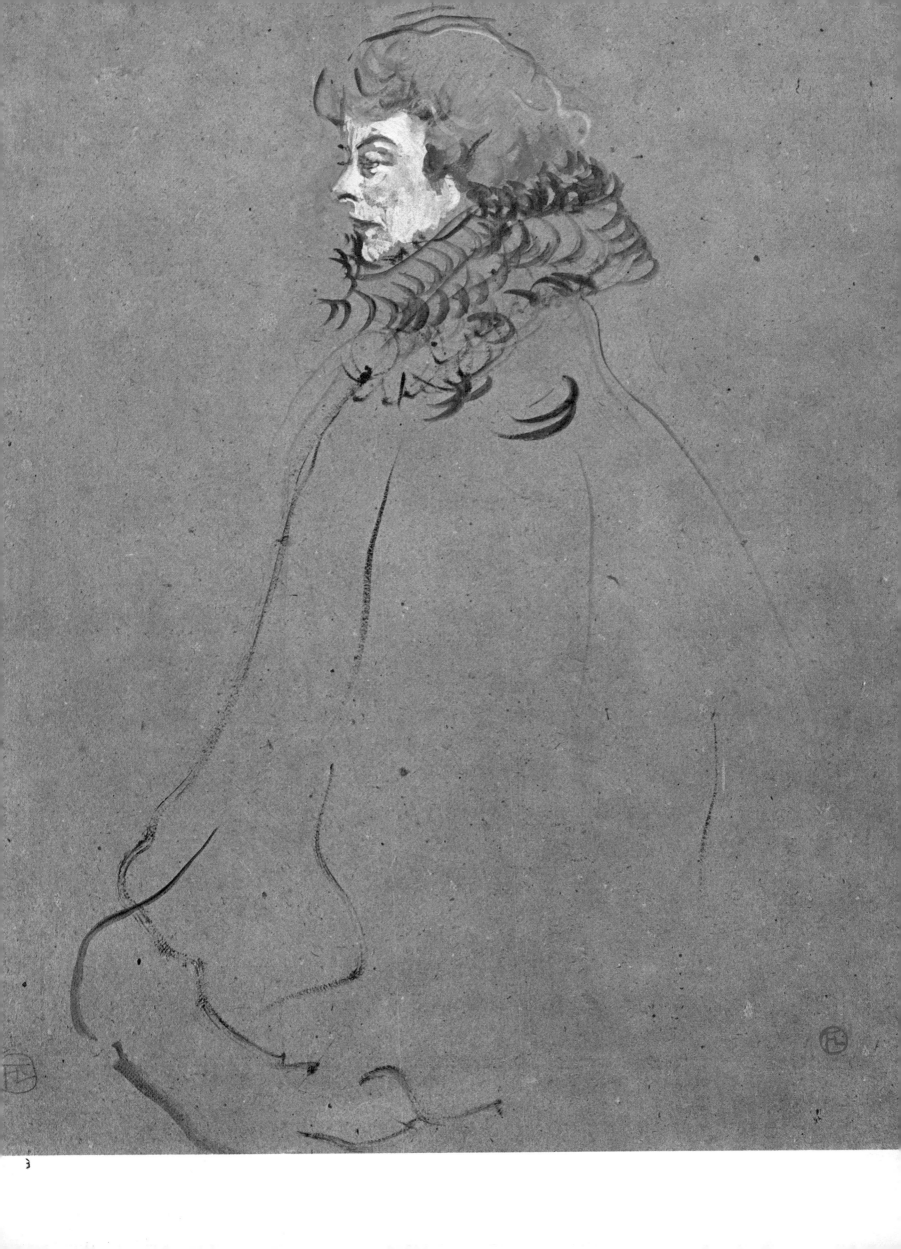

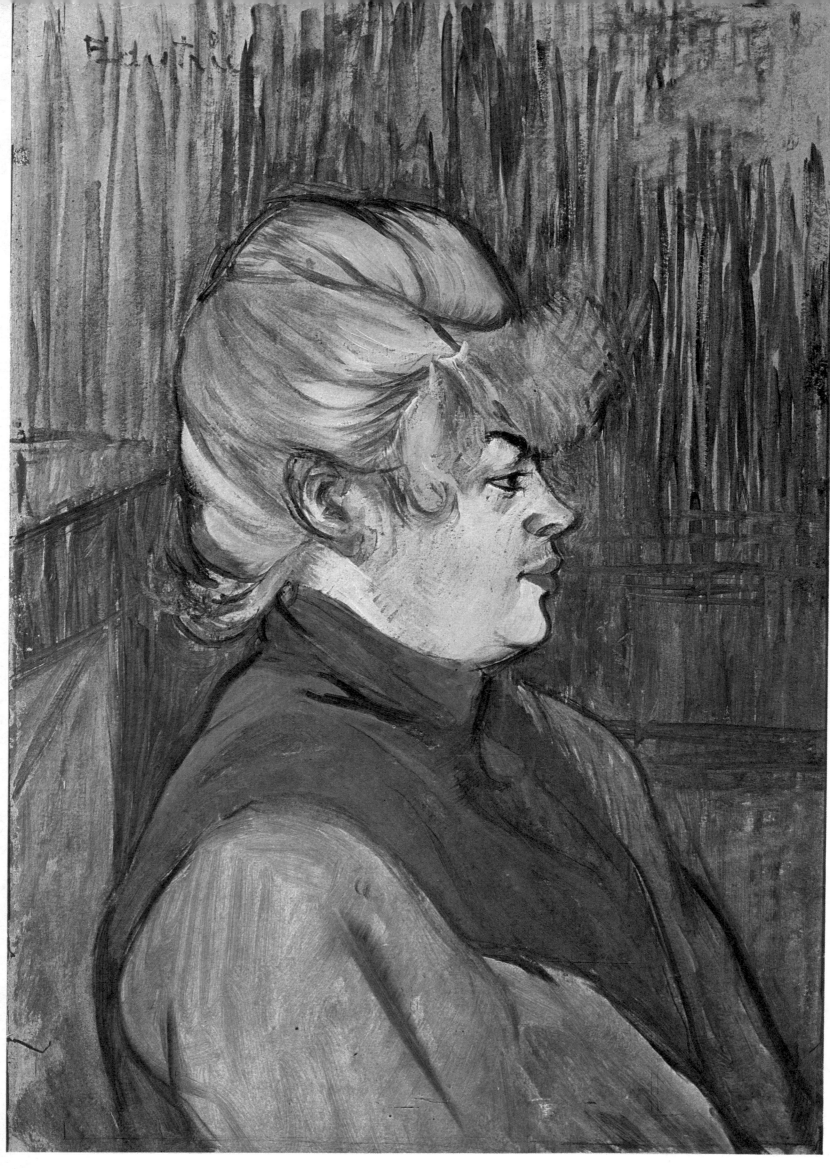

**Prostitute ("Femme de maison"), 1894. Oil thinned with turpentine on cardboard,
18³/₄ × 13 in. Paris, Private collection.**

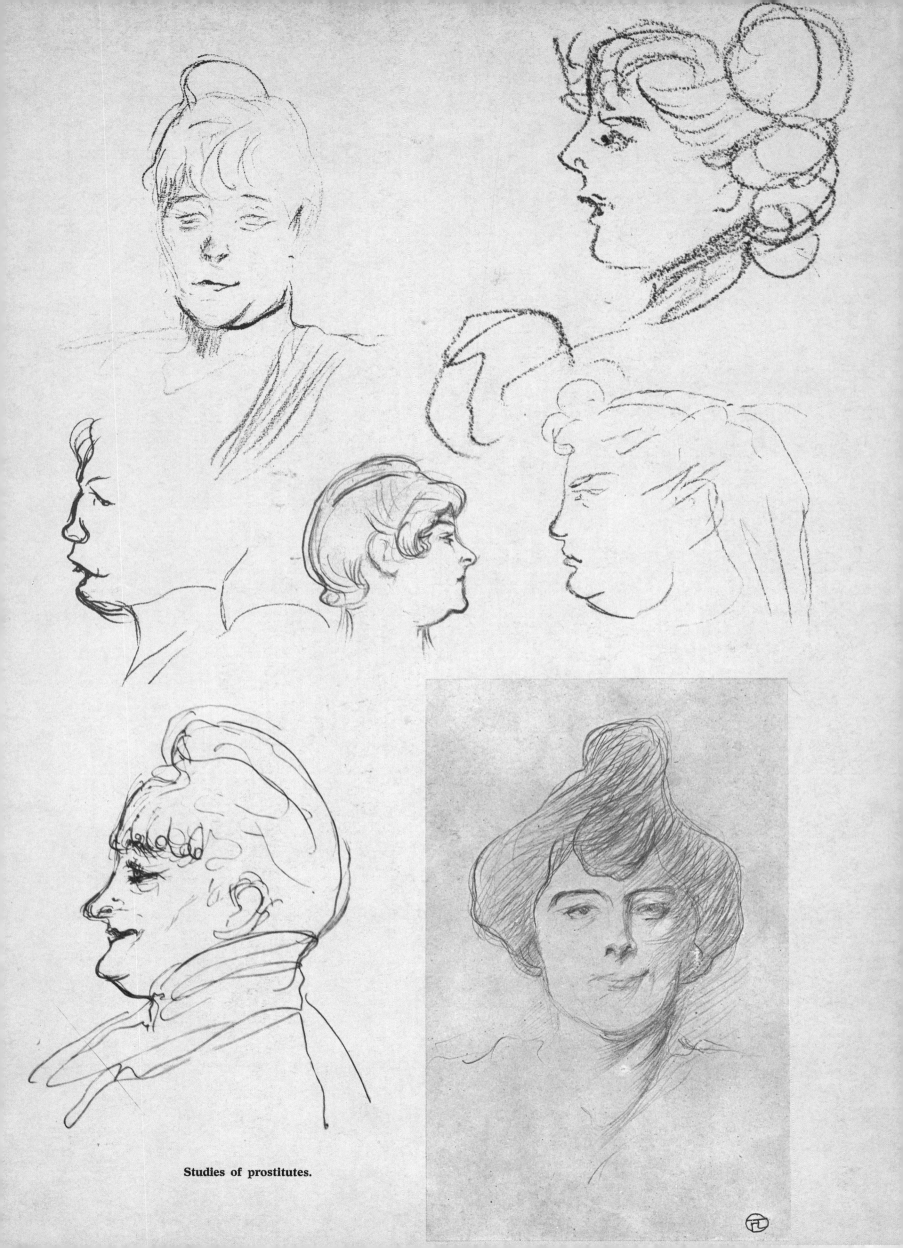

Studies of prostitutes.

1

day, which I think will put an end to the rumbling in my bowels. I'm going to set to work, having organized nothing as yet since my time was taken up with glaziers and chimney sweeps—which is no fun. My pictures keep on being sold, without my being paid for them yet. Bourges is very busy at the moment, so that I see little of him. I nearly always dine with Papa, Aunt Odette, and Monsieur Beyrolles, who is very agreeable and who even carried his kindness to the point of visiting my show at Goupil and not being dismayed at it. Papa, I believe, is going to leave for some hunting with a Monsieur Potain, Pothain, or Pothin, and I too leave you now with much love. Fond wishes to grandmother and to my uncle and aunt, who welcomed me so courteously. Your boy [*sic*] Henri. "

And, on another occasion:

" My dear Maman,

I beg your pardon for having written so little to you, but I'm swamped with my work, and rather dazed betweentimes. There seems to be an endless number of errands, mixups, appointments, etc. I have even taken up a new occupation, designing stage scenery. I am to do the sets for a play translated from Hindustani, something called *The Terra-cotta Chariot*. It is very interesting but is not easy. Anyhow, I mustn't count my chickens before they hatch. After the Odons leave, I'll try to come down to Albi and say hello. Would you be ready to come back with us? Gabriel would join us. Icy streets in Paris yesterday, with horses strewn all over the place.

With much love. Yours. "

But generally Lautrec kept very different company. He reveled in the shady nightlife of Montmartre. Its slopes were still covered with vineyards; atop the hill the Basilica of the Sacre Cœur was now under construction, but most of the houses there were still small and low. For half a century, as the nearest village of winegrowers to Paris, it had been the haunt of impecunious or nature-loving artists and writers, of craftsmen and workmen, but also of criminals, prostitutes, and other outcasts, who found in this maze of gardens, vineyards, and windmills a safer refuge from the prying eyes of the police than elsewhere in Paris. In the Montmartre of that day, which had all the charm of a world without class distinctions, Lautrec felt perfectly at home.

Every now and then Lautrec had a way of disappearing abruptly. He would go off in a cab with a suitcase, accompanied by one of his close friends, such as the poet and playwright Romain Coolus ("Coco") or Doctor Bourges or the loyal Maurice Guibert, as if he were leaving on a long journey. On such occasions he might be away for a week or two. But the cab took him only a few hundred yards, or just far enough to set him down at one of those "houses" in Rue de Richelieu or Rue des Moulins which the law condoned and bourgeois morality pretended to frown on. With his room reserved well in advance, Lautrec would solemnly announce his imminent departure to his friends. He then took up residence in the house as methodically and ceremoniously as if beginning a cure at a spa or making a retreat in a monastery.

When Yvette Guilbert asked him for his address one day, he coolly gave her the number of a well-known brothel in Rue d'Amboise where he happened to be staying. Her scandalized reaction—doubly amusing, considering the salacious songs she so often sang herself—delighted Lautrec enormously. And another time, when Paul Durand-Ruel, the noted dealer of Renoir, Manet, Degas, and Monet, asked to visit Lautrec's studio, the artist told him to come to a house in Rue des Moulins where he was then staying. There the austere defender of the Impressionists found Lautrec amid his canvases and a bevy of nude or half-clad models. The dealer's coachman was thoroughly shocked at this scene. "How can you live in such places?" the painter was asked in public by a fashionable married man who was sitting at a table with his mistress and whose own life was by no means blameless. "You, I know, prefer to have the whoring done at home!" exclaimed Lautrec in response.

To these places of ill repute he also liked to lure left-wing journalists and censorship officials. His greatest joy was to send such earnest, righteous people home roaring drunk or utterly exhausted after a night of carousing, while remaining perfectly sober himself. But he did not go to these houses merely for diversion. The personal charms of their inmates may have held little attraction for him; yet for his artistic purposes these were perfect models not to be found elsewhere, entirely without affectation or social guile. Several great writers of his day—Zola, the Goncourt brothers, and Maupassant—and such artists as Guys, Degas, and Forain had been similarly attracted by the world of prostitution. But Lautrec alone went beyond anecdotal, picturesque qualities; and because of his genuine affinity for people, whatever their place in life, he was able to give a faithful and moving record of this social phenomenon. There is nothing vulgar or lewd or even of questionable taste in his pictures of

1 **In Bed.** Crayon, 3¹⁄₈ × 4 in.
2 **In Bed, c. 1892–1895.** Cardboard, 27³⁄₄ × 21¹⁄₄ in.
 Paris, Musée du Louvre. (Photo Josse)

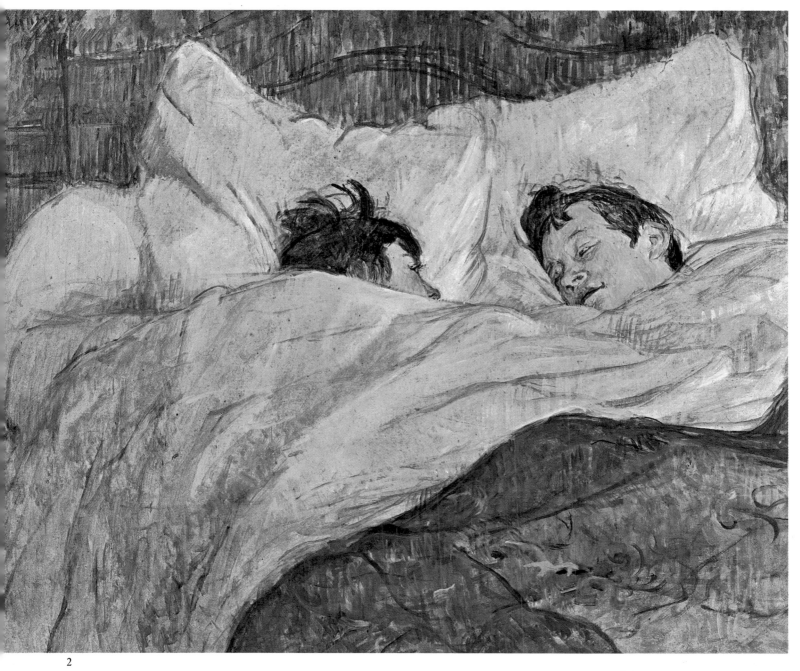

2

these cloistered prostitutes. His large painting *In the Salon*, for instance, showing the girls on view, is straightforward, almost chaste in its way. This was the outcome of many studies from life in which he overlooked no detail, yet without ever trying for any shock effect. What could be more terrible, more simple, more moving than his picture *Solitude*, showing a redhead alone and forsaken, lying listlessly on a bed, without having bothered to take off her black stockings? He often portrayed women in bed together or fondling each other, as if such lesbian affection were their only refuge after the constant defilement of commercial lovemaking. In a long series of paintings, draw-ings, and lithographs, he shows these women of the *maisons* dressing, washing, having breakfast, preen-ing themselves in a mirror. Gen-erally they are not very pretty, but have something more than mere looks: they are human, touching, and memorable personalities.

"Among these women," wrote Fran-cis Jourdain, "Lautrec is like some

LA BELLE ET LA BÊTE

PAR R. COOLUS ET TOULOUSE-LAUTREC

IL y avait une fois une princesse qui était belle comme le jour ; elle était même plus belle que le jour, car ce dernier ne se gênait pas pour, de temps à autre, se lever gris et pluvieux, tandis que la princesse se levait toujours blanche et rieuse.

Cette princesse avait pour père un vieux Roi très fainéant ; il passait tous ses après-midi à faire des parties de bézigue chinois avec son chambellan ; ce dernier n'hésitait pas à perdre quatre fois sur cinq ; aussi le vieux Roi trouvait-il le bézigue chinois le plus amusant des jeux et son chambellan le plus spirituel des fonctionnaires.

Si la princesse avait compté sur son royal père pour travailler à son éducation, elle eût sans doute été considérablement déçue ; mais c'était une princesse non moins avisée que belle, et qui de bonne heure avait pris le parti de se diriger elle-même : elle s'entoura des maîtres les plus illustres, apprit le dessin, peignit sur porcelaine, exécuta des valses brillantes et devint une virtuose de la vocalise.

Quand elle eut acquis toutes les perfections, inclusivement, elle fit venir son père et lui tint ce langage :

« Je suis belle comme le jour, c'est convenu ; j'ai plus de qualités à moi toute seule que toutes les autres filles de la contrée réunies. Que comptez-vous faire de moi ?

— Te marier ! répondit distraitement le vieux Roi.

— Ah ! c'est tout ce que vous avez d'intéressant à me proposer ?

— Dame !

— Pardon, demoiselle ! Me marier, moi ! et sans raison ! Car avez-vous la plus petite raison de me marier ? Répondez.

— J'ai une excellente raison, excellente et que voici : J'ai soixante-treize ans ; tu en as vingt ; tu es à l'âge où on marie les filles ; moi, je suis à l'âge où on les quitte ; je ne veux pas te laisser seule et abandonnée sur cette terre, pendant que j'irai faire connaissance avec le dessous. Tu es fille, tu es nubile ; il ne manque pas de princes héritiers ; tu seras reine. Cela fait partie de ta carrière ; tu n'as pas le droit de refuser de l'avancement.

— Par don ! je veux bien être Reine, mais je ne veux pas être la femme d'un Roi qui me déplairait. J'accepterai le mariage s'il se présente sous un aspect séduisant : jolis yeux, lèvres fines, discours tendres et tournure preste ; mais je vous préviens que je n'épouserai qu'à ces conditions ; je veux choisir mon maître.

— Bon, dit le vieux Roi, tu agiras à ta guise ; tu n'as pas lu trop de romans ; je ne redoute pas de bêtises. Mais si tu veux me faire plaisir, tu te dépêcheras. Pour l'instant, il faut que je te quitte ; mon chambellan m'attend depuis un gros moment, et, comme il est plus joueur que les cartes, je crains qu'il ne se bile et ne devienne jaunâtre, à la façon des citrons. »

Sur ce, le vieux Roi s'en fut dans la chambre voisine et gagna la partie.

.˙.

Lorsqu'on apprit dans le monde que la princesse, celle que l'on appelait *La Belle*, était désireuse de convoler en justes et somptueuses noces, tous les princes, ducs, seigneurs de tout acabit se grattèrent simultanément l'oreille droite et murmurèrent à peu près en chœur : « Diable !!! » La princesse constituait un admirable parti ; d'abord elle était d'une beauté radieuse, d'une beauté telle que près d'elle filles et femmes les mieux visagées paraissaient fades, de teint anémique et d'yeux sans rayons ; ensuite elle possédait des territoires si étendus que les revenus eussent suffi à l'entretien de trois peuples ; enfin il était très certain que son mari ne connaîtrait jamais l'ennui, car son esprit avait des dons merveilleux de subtilité et de grâce ; en outre, elle jouait des valses brillantes et excellait dans la vocalise.

Ces considérations expliquent qu'à partir de ce moment la capitale du royaume de *La Belle* vit accourir des princes suivis d'escortes éclatantes, des seigneurs menant train fabuleux, des sultans et des émirs accompagnés d'éléphants et de bayadères. Des fêtes extraordinaires furent données où ces illustres hôtes disputèrent de luxe et rivalisèrent d'imagination. La princesse assista à ces réjouissances avec une indifférence parfaite, et lorsque son père la pria de se prononcer et de choisir parmi ces candidats d'élite : « Je suis fâchée de ne pouvoir encore vous satisfaire, répondit-elle, mais aucun de ces messieurs n'a eu l'heur de se faire distinguer. Ils sont tous sans intérêt ; ce sont des sots qui désirent mes biens et ma couronne ; il n'en est pas un, je l'atteste, qui m'ait regardé autrement que comme une marchandise de prix. Je préfère ne pas me marier, s'il faut que je devienne la compagne, pour ne pas dire l'esclave, d'un de ces ridicules roitelets. Attendez, mon cher père, patientez ; peut-être viendra-t-il, le fameux prince charmant ; en tout cas, pour tuer le temps et vous consoler, vous avez toujours votre chambellan ; il est peut-être à l'agonie, mais il n'est pas encore défunt. »

.˙.

Un à un, les princes dépités se retirèrent, très vexés dans leur amour-propre princier, fâchés aussi d'avoir fait des dépenses considérables sans le plus léger profit. Leur seule consolation fut, pour chacun, d'être éconduit avec tous les autres, et de ne s'être vu préférer personne. Ils s'en revenaient aigris, et l'opinion qu'ils avaient maintenant de la princesse lui était beaucoup moins favorable qu'au jour de leur arrivée. Ils s'étonnaient qu'on l'eût appelée *La Belle*, comme si elle était la seule belle fille de la terre ; ils estimaient son esprit vulgaire, sa conversation sans éclat, ses talents lyriques quelconques ; il n'y avait que ses importantes richesses sur qui leurs pensées n'eussent pas varié ; ils persistaient à les juger avec complaisance et ils eussent éprouvé un plaisir certain à se les adjuger.

La princesse se moquait des mauvais bruits et des méchantes rumeurs répandues sur sa conduite et son caractère ; elle se savait assez belle et bonne pour faire la joie de l'homme qu'elle aimerait, et cette pensée suffisait à maintenir sur ses lèvres un sourire

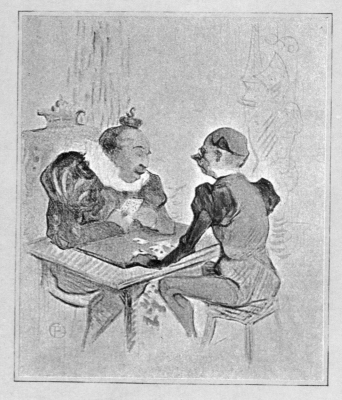

merveilleux. Cependant elle soupirait un peu ; le prince charmant se faisait bien attendre.

Un an se passa. *La Belle* demeurait insensible ; pourtant un roi d'Egypte venait de se tuer par amour pour elle, après avoir fait un certain nombre de folies invraisemblables et décrété que cinquante crocodiles, choisis parmi les plus sensibles du Nil, suivraient ses funérailles et y pleureraient en cadence ; un prince de Hongrie venait, par dépit d'être refusé, d'épouser une danseuse dont la réputation n'était pas moins légère que les gazes bleues et roses flottant autour de son corps ; enfin deux comtes et quelques vicomtes, six baronnets, neuf chambellans et cent dix-huit étudiants (droit, médecine et même théologie) se mouraient d'amour pour elle, sans autre dam pour leur santé. *La Belle* demeurait insensible, attendant son prince charmeur ; et le vieux Roi continuait à gagner son chambellan exténué, sans éprouver la moindre surprise de sa veine inépuisable.

...

La princesse avait l'habitude, les soirs d'été, de se promener dans le parc du château. Sous le ciel clair et fourmillé d'étoiles, il était délicieux de s'attarder ainsi près des parterres et des arbres.

Voici qu'une nuit, pendant qu'elle remontait l'allée principale, si finement sablée que nul pas ne s'y révèle, elle vit se dresser devant elle une ombre lourde et forte.

« Qui est là ? s'écria *La Belle*, qui est là ? »

Mais nulle voix ne répondit ; la belle princesse sentit seulement deux bras velus et puissants autour de son cou.

« Ah ! Dieu ! murmura-t-elle ; je suis morte ! C'est une bête ! »

C'était une énorme bête en effet, au pelage soyeux et doux. Elle tenait la princesse contre elle, sans lui faire de mal, tendrement.

« C'est peut-être une bête amoureuse de moi », pensa aussitôt la princesse. Et elle fut immédiatement rassurée.

Cette idée en soi n'avait rien d'absurde, puisque *La Bête*, après avoir mis une patte respectueuse sur les lèvres de la princesse, lui murmura ces quelques mots remplis de sens : « J'appartiens au règne animal, je ne le contesterai pas ; mais les hommes aussi d'ailleurs, tous les naturalistes dignes de foi vous en assureront, et j'entends que vous m'aimiez, car je vous aime comme aucun homme jamais ne vous aima. »

La voix était mélodieuse, la patte était parfumée et, chose curieuse, au lieu de sentir le musc brutal, elle fleurait délicatement l'iris ambré. Mais *La Belle* ne s'arrêta pas à ce détail ; elle fut seulement très flattée qu'une bête aussi hirsute et formidable eût subi le charme de sa beauté au point de venir lui faire, dans son propre parc, en termes presque spirituels, une déclaration passionnée.

Aussi lorsque *La Bête* audacieuse eut le front de déposer sur celui de la princesse un baiser prolongé, *La Belle* jugea-t-elle inopportun de se plaindre et déplacé de récriminer ; elle se laissa faire, et, quand je dis qu'elle se laissa faire, j'entends qu'elle le lui rendit.

Cette cour originale se poursuivit plusieurs soirs de suite ; *La Belle* était très amoureuse de *La Bête*, et le parc fut à la fois témoin et complice de scènes vraiment émouvantes ; c'est ainsi que le côté jardin parfois se marie avec le côté cour. *La Belle*, qui avait dédaigneusement repoussé les hommes et leurs hommages, souffrait très volontiers *La Bête* et ses bêtises.

. .

« Eh bien ! puisque vous m'aimez, ma mie, marions-nous donc, dit un jour à la princesse, après un duo chaleureux, le jeune seigneur qui venait de faire sauter sa tête d'ours et tenait sur le bras sa défroque parfumée. J'ai assez fait la bête pour vous plaire.

— Ah ! répondit *La Belle* déçue. C'est fâcheux ! Il eût mieux valu en être une que de le feindre. J'étais très décidée à vous accorder ma main quand vous m'offriez votre patte. Mais maintenant... Tous mes compliments à votre fourreur, mon cher ; vous étiez très réussi. »

Et elle s'en fut retrouver son père qui achevait de gagner sa six mille troisième partie de bézigue céleste.

ROMAIN COOLUS.

(Illustrations de Toulouse-Lautrec.)

Two pages from "La Belle et la Bête," illustrated by Lautrec.

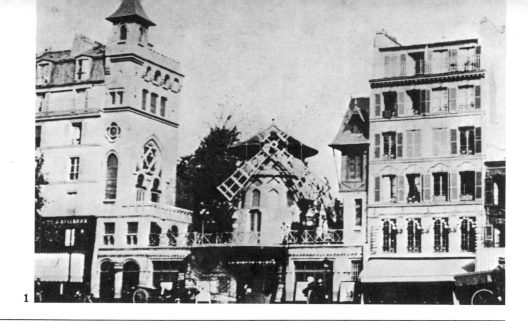

1

spoiled child, so amiably tyrannizing them. They appreciate his friendly simplicity, which never trades on the fact that he not only is a famous artist but also bears a most illustrious family name. These companions would have been embarrassed had they sensed any condescension on his part or any sort of insolent pretense of passing himself off as a lawbreaker or a tough guy. He is what he is." They called him Monsieur Henri the Painter. No one wondered at his presence. He would wander about, thumping his cane on the floor and singing patriotic songs at the top of his voice, such as "The Song of Departure" or "The Republic Calls, The Republic Awaits Us." The girls would sit around playing cards, eating, or humming sentimental tunes with him and maybe talk over their blighted hopes or about their "little man" who had to be provided for. Monsieur Henri was accepted as one of the crowd.

Lautrec very eagerly collected letters, snapshots, and other mementos of the girls. To his friend the engraver Charles Maurin he once showed a snapshot of two of the girls snuggling up to each other. "That beats everything," he declared. "Nothing can match something so simple as that." Another time he showed Leclercq an announcement of the coming marriage of one of the girls. The wedding card was issued collectively, in the name of "the ladies of Rue des Moulins." To this, Lautrec remarked: "That's not nice, now is it?"

One girl, Mireille, was a favorite of his. She is shown in profile in the foreground of his large canvas *In the Salon*, sitting holding one leg doubled up and with the other outstretched. They are trying to tease me," he told François Gauzi. "They hide Mireille when I ask for her, so I made up my mind to pay her

2

for a day off [when I wish to see her]. I write to her and she never fails to come and see me. She was here yesterday." Then he pointed to a bunch of violets in a vase. "Mireille's doing," he said. "She bought it on her way here and then kindly presented it to me." Later he told Gauzi: "Mireille's off for Argentina. Some meatpackers have convinced her she can make her fortune out there. I've tried to talk her out of it, but she really believes all their claptrap. None of the girls who go there ever come back. After two years of it, they're finished."

Elles ("Shes") was the title of a set of lithographs commissioned from him by the publisher Gustave Pellet, picturing these women, these "true" women who, either from necessity or by choice, offered their bodies for hire. In various ways Lautrec admired them, probably since he found in their unconstrained spontaneity the frankness and sincerity he so prized above all other qualities. Yet there are spiritual overtones in each of Lautrec's works, for it was precisely in the ugliest, most despised denizens of society that he found the most perfect, most disembodied beauty. As Christ spoke of the wellsprings of joy through self-sacrifice and suffering, so Lautrec teaches us the universality of the spirit and of

beauty, which lie not in choosing only what one desires to see, but quite simply in learning to see—that is, to see and appreciate things as they are.

Lautrec divided his time between the brothels and the music halls, seeking female inspiration there as well. He fell under the spell of a dancer, clown, and woman of easy virtue who pretended to be Japa-

3

1 Photograph of the Moulin Rouge.
2, 3 Two photographs of Cha-U-Kao.
4 The Clowness Cha-U-Kao, 1895. Canvas, 29½ × 21⅝ in.
 Winterthur, Collection Oskar Reinhart am Römerholz.

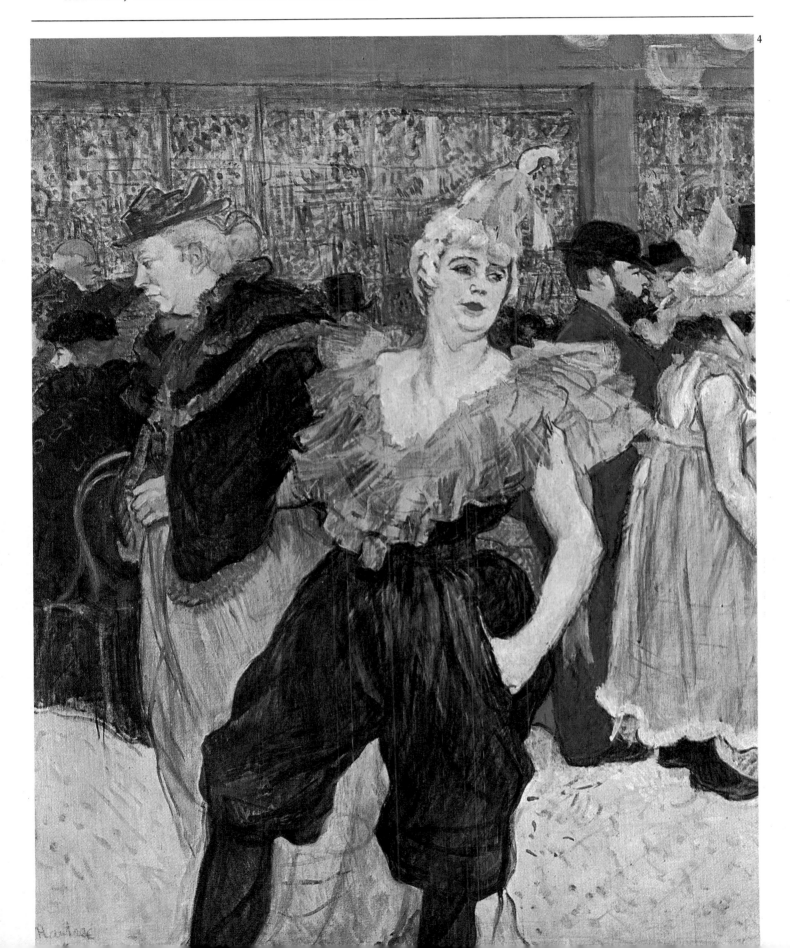

**In the Salon, Rue des Moulins, 1894.
Canvas, 44 × 52¼ in.
Albi, Musée Toulouse-Lautrec.**

nese and called herself Cha-U-Kao (from a play on words, *Chahut-Chaos*). Several of his finest pictures show her in fancy dress leading a masquerade, strolling in the Moulin Rouge, or performing in the ring at the Nouveau Cirque.

But Louise Weber, better known as "La Goulue" (The Glutton), held an even greater fascination for Lautrec; for him, she was charm personified. "Ah, life!" was a favorite phrase of the painter, and this sixteen-year-old buxom blond *fille de joie*, a true glutton for pleasure, whom he saw dancing nightly for her own amusement at the Moulin de la Galette was the very image of life. He drew and painted her over and over and used her often for his illustrations and lithographs. In her lust for life, her audacity and passionate appetites, he recognized a kindred soul; and she in turn saw in him the painter best able to appreciate her— her painter. He followed her about and admired her when she danced the "naturalistic quadrille" at the Elysée-Montmartre dance hall in the Boulevard de Rochechouart. With the coaching of the male dancer Auguste Renaudin, known as Valentin le Désossé, she acquired a spectacular technique and from her first appearance at the Moulin Rouge, publicized by Lautrec's celebrated poster, enjoyed great success.

Yvette Guilbert saw her dance there and described her thus: "La Goulue in black silk stockings, holding her black satin foot in one hand, would set the sixty yards of lace in her skirts whirling and show her panties, whimsically embroidered with a heart that stretched over her little bottom when she took her raffish bows. Behind the tuft of pink ribbons at her knees and an adorable froth of lace reaching to her slender ankles, her nimble, shapely, sprightly, and alluring legs would appear and disappear. With a smart little kick of her leg she would knock off her partner's hat, and then she

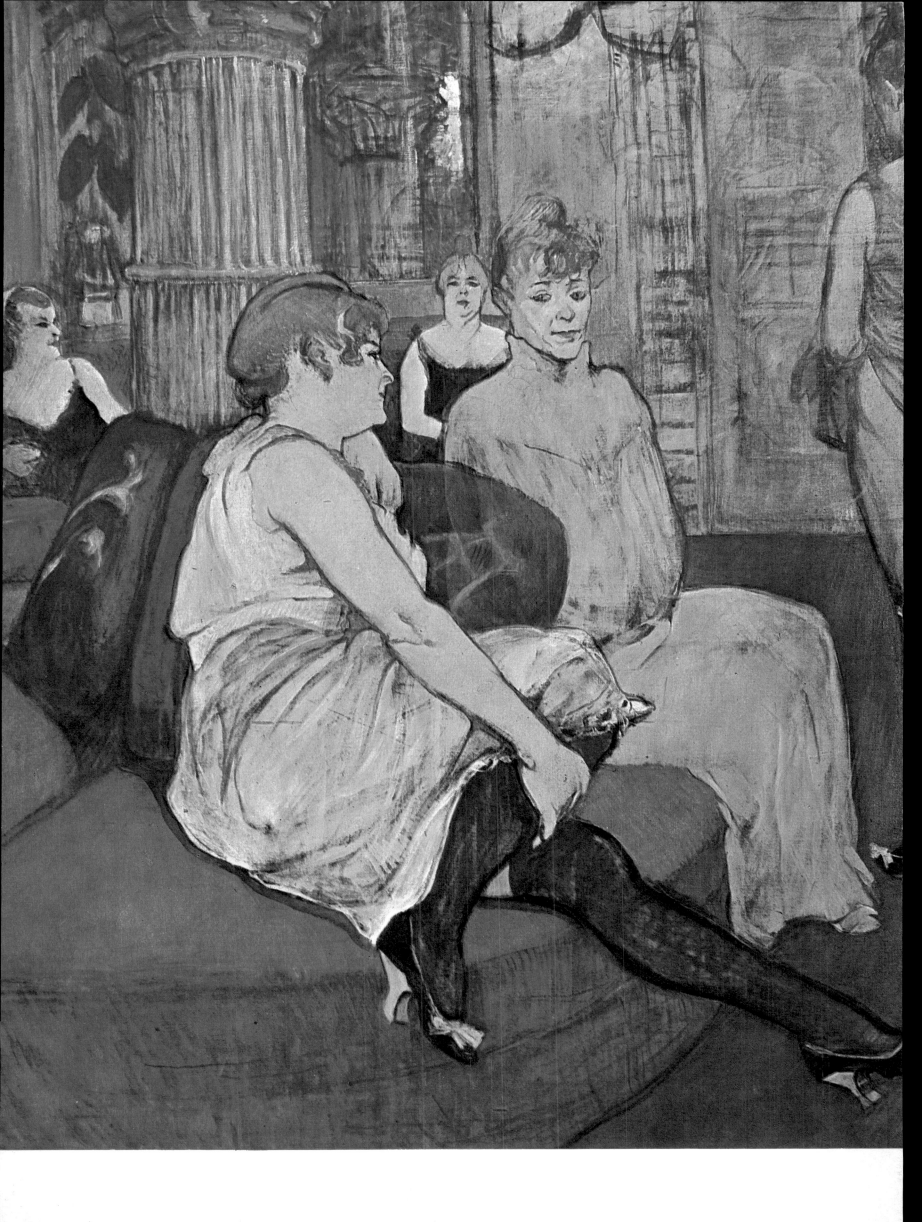

La Goulue Entering the Moulin Rouge, 1892. Cardboard, $31^7/_8 \times 23^5/_8$ in.
New York, The Museum of Modern Art, Gift of Mrs. David M. Levy.

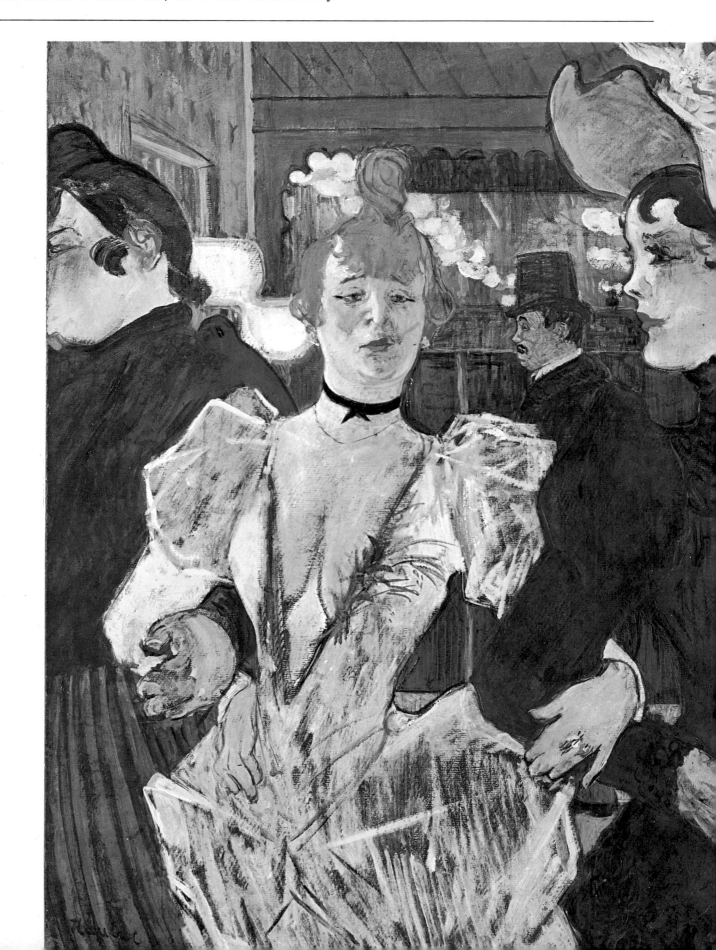

1

2

"My dear friend,
I will call on you Monday, April 8, at 2 P.M. My booth will be at the Trône fairground, on the left as you come in. I have a very good location and will be glad if you have time to paint something for me. You tell me where to buy the canvases, and I'll get them to you the same day.
La Goulue."

The painter set to work at once and decorated her fair booth with two large canvases that are now one of the glories of the Louvre. These represent La Goulue dancing before a group of their friends. But after a short run at the Foire du Trône, La Goulue began to go downhill. She went from lover to lover, just as she regularly changed from one line of show business to another. She eventually took up animal taming, was injured, and sank into hopeless poverty. In 1925, when she was in her fifties, Pierre Lazareff came upon her in a fair booth surmounted by a banner that proclaimed "Here is the famous Goulue of the Moulin Rouge dance hall." A barker was trying to lure customers by telling odd bits about the dancer's notorious past. "It was a mockery. The curtain opened to reveal a fat hag in shabby clothes, a mountain of flesh with a hideous grin on her face. ... Our interest did not keep her from indulging herself, so without even turning her head, sitting on a packing case at one end of the platform, she drank up a whole liter of cheap red wine straight from the bottle. When she had finished this, she smacked her lips with satisfaction, wiped her mouth with the back of her hand, and spat on the ground with a chuckle. ... We tried to get her to talk: 'Those were the good

old days, eh, my dear? Remember?' She repeated the words in a thick voice, punctuating them with snickers: 'Do I remember, you say! The girls knew a thing or two then, and the men were up to anything. What fun it was!' Impossible to get anything more out of her. We tried, but no use." After living for a while on handouts in a shanty on the outskirts of Paris, Louise Weber—the celebrated Goulue—out of pity was given a job as maid in a brothel. A few years later, in 1929, she died destitute in the Lariboisière Hospital.

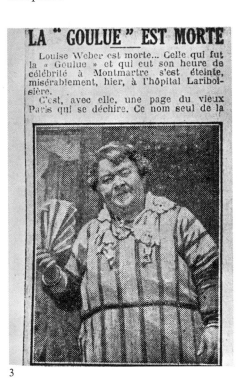

LA "GOULUE" EST MORTE

Louise Weber est morte... Celle qui fut la « Goulue » et qui eut son heure de célébrité à Montmartre s'est éteinte, misérablement, hier, à l'hôpital Lariboisière.

C'est, avec elle, une page du vieux Paris qui se déchire. Ce nom seul de la

3

Lautrec was most prolific and at the height of his powers in this period, when he was so fascinated by La Goulue and Cha-U-Kao and spent so much time in the "houses" of Paris. His output between 1892 and 1895 was prodigiously rich and varied. In addition to paintings, he produced some brilliant lithographs, his finest posters, a large number of illustrations for books and periodicals, and even some stage décor.

would do splits, with her torso erect, her slender waist wrapped in her sky-blue satin blouse, and her black satin skirt opening like an umbrella and spreading out for five yards around her. What a magnificent sight! La Goulue was pretty and pertly tantalizing to look at, with a fringe of blond hair falling over her forehead right down to her eyebrows. Bunched up on top of her head and coiled tightly at the nape of her neck, her hair was arranged so as not to get in the way during her numbers. From her temples the classic lovelocks hung down in ringlets over her ears, and from Paris to New York, by way of London's East End slums, all the girls of the period wanted a hairdo like hers, with that same colored ribbon wound around their neck."

After successfully headlining at the Moulin Rouge for three years, La Goulue had enough of its noisy crowds and foul smoke-filled air, so she decided to put on a show of her own. On April 7, 1895, Lautrec received the following note from her:

1 Photo of La Goulue's booth at the Foire du Trône, decorated by Lautrec in 1895.
2 Louise Weber ("La Goulue") in her prime, photo.
3 La Goulue toward the end of her life, photo.

51

4 - THE LAST DROP

The Last Drop, 1887.
Pencil drawing with bister wash,
23 × 17³/₄ in.
Private collection.

When his friend Maurice Joyant succeeded Theo van Gogh, Vincent's brother, as manager of the famous Goupil Gallery, the matter of organizing a Lautrec exhibition was soon discussed. But the young painter hesitated and only accepted the proposal in 1893. To his surprise, the press reviews were by no means hostile. The exhibition had the honor of a visit from Degas. "One evening toward six," wrote Joyant, "Degas turned up, in his Inverness cape, and carefully examined all the pictures, while humming to himself. He made the rounds without a word and was just about to go downstairs, when, with only head and shoulders emerging from

the spiral stairway, Monsieur Degas turned and said to Lautrec, standing there timid and anxious: 'Well, Lautrec, I see you are one of us.'" And Joyant added: "I can still see Lautrec beaming with inner satisfaction at this casual word of approval." It is worth noting, too, that at this first gallery showing Lautrec's paintings

of the "houses" were on view only to friends and recognized collectors in a closed room upstairs, in order not to provoke a public scandal.

A year later, in May 1894, during a Manet exhibition, Durand-Ruel also showed a set of lithographs by Lautrec—a signal honor for their creator. The final Lautrec exhibition organized during the artist's lifetime, again on Joyant's initiative, took place in 1898 at the Goupil Gallery in London.

By now the young dealer was truly worried about his friend's health, for Lautrec looked out for himself less and less: he slept very little, drank too much, and either worked through the night or stayed out till morning in the bars and music halls. One day he turned up at 8 A.M. at Joyant's and found him sound asleep. Waking him, Lautrec pulled out a crumpled paper with his extraordinary lithograph *A Sleeping*

Woman, the outcome of studies made in the houses of prostitution: "A master drawing, my dear sir," declared Lautrec, "done at daybreak." And this work is indeed one of the finest, most arresting he ever produced.

His hard drinking was not noticeably deterred by the trip to London for his exhibition, though he was jolted by the rough treatment given the street drunkards by the English policemen. "All right," he conceded, "better drink only a little—but often." As he acted on this principle, his health began to break down. "One must get drunk. That's the whole point. In order not to feel the horrible load of years crushing you down into the ground, you've got to get drunk, and with no truce in between. But on what? On wine, on poetry, or on virtue, whatever you like. But get drunk. And if sometimes, on the steps of a palace,

1 **Caricature of Dr. Tapié de Céleyran Dressed as a Turk, 1895.**
Cardboard, 9⅞ × 3¼ in. Paris, Collection of Madame M. G. Dortu.
2 **Dr. Tapié de Céleyran at the Comédie Française, 1894.**
Oil on canvas, 43¼ × 22 in. Albi, Musée Toulouse-Lautrec.
3 **Yvette Guilbert, 1894. Design for a poster on manila paper,**
73¼ × 36⅝ in. Albi, Musée Toulouse-Lautrec.
4 **Loïe Fuller, 1892. Oil thinned with turpentine on tracing paper**
mounted on cardboard, 18⅛ × 12⅝ in. Paris, Private collection.

4

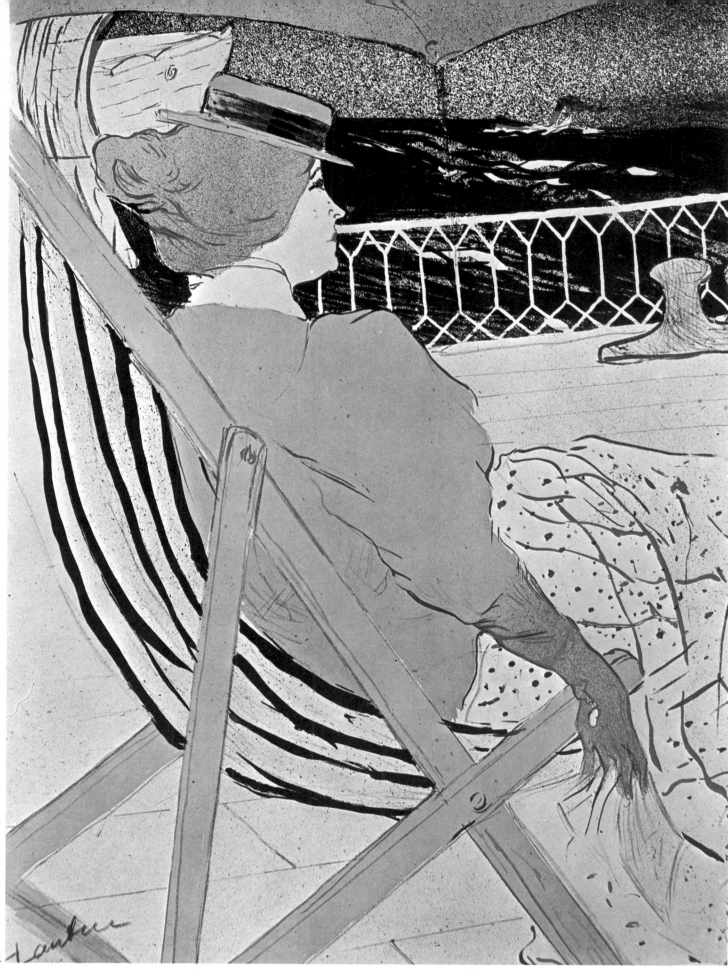

on the green grass of some embankment, or in the bleak solitude of your room, you wake up and your drunkenness has subsided or gone away, then ask the wind, the wave, the star, the bird, the clock, ask everything that rushes off, everything that wails, glides, or sings, everything that talks, ask what time it is. And the wind, the wave, the star, the bird, the clock will answer you: 'It is time to get drunk! So as not to be the tormented slaves of time, get drunk and stay that way! On wine, on poetry, or on virtue, whatever you like.' "

In a room with barred windows and a padlocked door in a fine house in Neuilly, on the edge of Paris, a former residence aptly called "St. James's Folly" and now a private mental home: it was here that Lautrec woke up one day from the drunkenness extolled by Baudelaire. He was not mad, and he knew it. But his family and friends had confused with madness the excitable, nervous state brought on by overwork, heavy drinking, sleeplessness, and a continuous round of pleasure-seeking in all the haunts of Paris nightlife. Certainly he seemed more and more weak and exhausted. In

2

3

4

1 **The Unknown Lady Passenger
of Cabin 54 on "Le Chili," 1896.
Lithograph, 24 × 16 in.**

2 **Lautrec in a boat with Viaud, photo.**

3 **Lautrec swimming at Le Crotoy,
photo.**

4 **The lady on board "Le Chili," photo.**

5 **Lautrec in a boat, photo.**

February 1899 he had a fit of delirium tremens and broke his collarbone in falling down. His cousin Gabriel Tapié de Céleyran and his friend Doctor Bourges had both urged his mother to see that he undergo a rest cure and detoxification. Maurice Joyant opposed this recommendation, but in vain.

Though interned in a mental home, Lautrec was anything but a madman; the lucidity of his mind is undeniably confirmed by every one of his paintings, drawings, and lithographs from this time. From the first week of March 1899, he was in the hands of male nurses who manhandled and drugged him with sedatives. When he finally came to, he rebelled and appealed to his father: "Papa, you have a chance to do a gentlemanly deed. I am shut up, and everything that's closed in dies." But Count Alphonse did not dare interfere. Then Henri became panic-stricken, for he remembered his friends Oscar Wilde and Van Gogh, on whom society had taken its revenge by treating them both as madmen and crushing them with that terrible judgment. One day he showed his friend Gauzi a print representing a madman by André Gill, an artist who had died in an insane asylum. "That's what's waiting for us," he said.

But he kept his head and struggled every inch of the way. As always, the psychiatrists were pessimistic in their initial diagnosis; it would, they said, take a long time to cure him. But Lautrec understood their methods and he parried their questions. "I'll always remember my first visit to Lautrec there," wrote Joyant later, "and my aching sadness. At the end of a narrow, low-ceilinged corridor, dimly lit by loopholes and closed off by a low door, were two little cells with tile floors and barred windows. One was his room, and the other his guardian's. Calm and lucid, already possessing pencils and some drawings, Lautrec welcomed me like a liberator, a link with the outside world, but also full of dread at the thought that, with the complicity of his family and his doctors, whether well-meaning or calculated, he might be locked up there forever."

After four or five days of drinking nothing but water, Lautrec felt much better. In two weeks' time he had pulled himself together. He made plans carefully, resolving to show by his everyday conduct and work that he was in full command of his powers as an artist and so prove that there was no need to keep him in confinement. To his friend Joyant, he wrote:

"Madrid [i.e., Rue de Madrid]
March 17, 1899

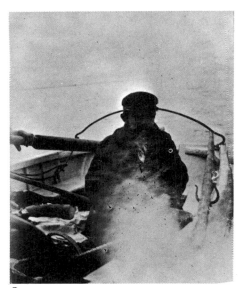

5

Dear Sir,
Thanks for your nice letter. Come and see me. *Bis repetita placent.* Yours, T.-L."

Elsewhere he continued: "Send me some grained stones and a box of watercolor with sepia, brushes, litho crayons, and good-quality India ink and paper. Come soon and send Albert as messenger. Bring a cam-

Animal drawings by Lautrec
for Jules Renard's "Les Histoires naturelles," 1897.
Paris, Bibliothèque Nationale.

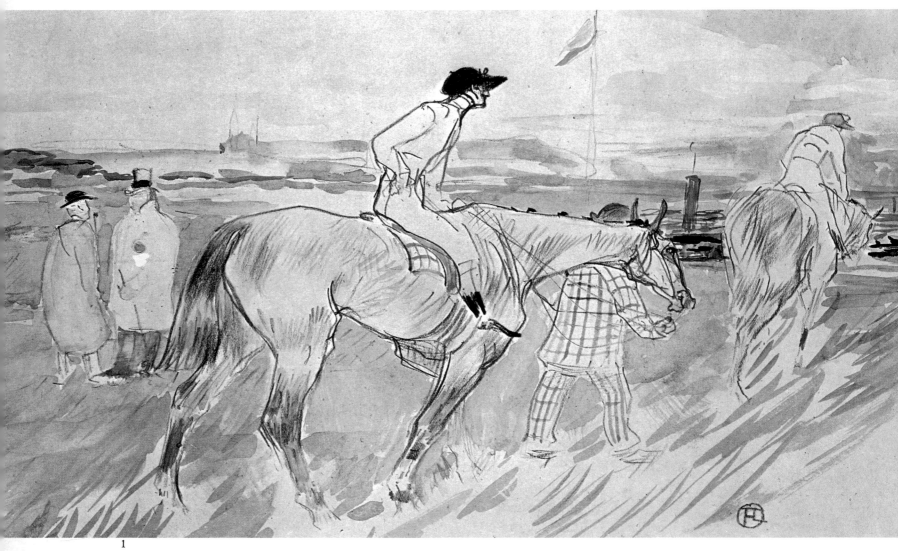

1

era; the garden is splendid, with Louis XV statues. It was a trysting place for lovers."

Joyant had the happy idea of commissioning a series of circus illustrations from him. Working in his sickroom with colored crayons, without oil or brushes, Lautrec made a truly stunning set of drawings, among his finest. He had always frequented the circus and loved its clowns and acrobats, all the ingenuous routines and daring feats of the ring. He equated the circus with life; its outlandish and comic performers, comprising a surreal parade of humanity more vivid than everyday life, came marvelously alive

in these drawings, all done from memory while he was confined in "St. James's Folly."

Even the doctors were impressed by his progress and gradually relented. "Monsieur Henri de Toulouse-Lautrec," they reported, "has become quite calm and wholly different from the state we found him in during our previous visits. ... It is certain that this most recent improvement can only last if the convalescent is kept in the same conditions of physical and mental hygiene for several more weeks." And on May 17: "He continues to improve physically and mentally. No symptoms of delirium have appeared. Signs of alcoholic

intoxication, apart from a slight trembling, are practically negligible. ... But owing to amnesia and his unstable character and lack of will-power, it is essential to keep Monsieur Henri de Toulouse-Lautrec under continuous surveillance."

Then, on May 20, he was released on probation. "There are still people," he said with a smile, "who think that sickness and the sick are made for them." But to Joyant, more seriously, he declared: "I bought my freedom with my drawings." He had been afraid, very afraid. What he had dreaded most was internment. So now, in exchange for his freedom, Lautrec the wildman accepted

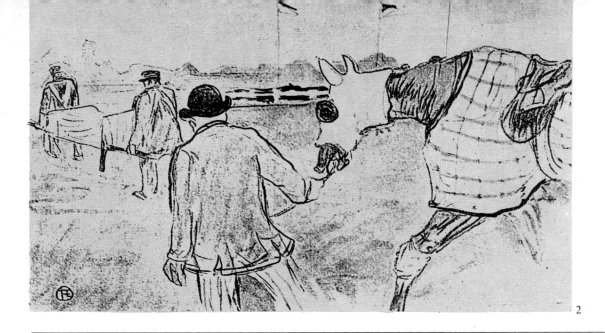

2

3

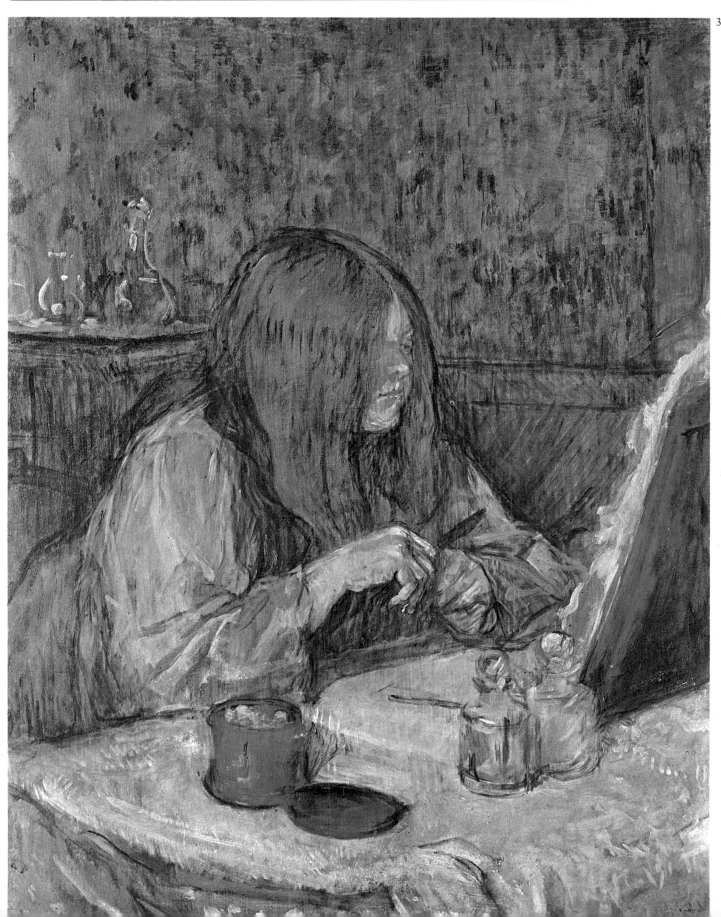

without grumbling a totally new, more disciplined way of life, radically contrary to his own natural inclinations. From then on, a family friend, Paul Viaud, was at his side day and night to keep him from drinking. All the while Lautrec, of course, did his best to induce his watchdog to drink, hoping to get him soused while remaining sober himself.

For a change of air, he next made a trip to Normandy and stayed four months in Le Havre and its environs. He haunted the bars, with their international clientele of sailors and fishermen, where the barmaids often sang and danced and picked up customers of their own on the side. He was entranced by the barmaid at the Star, Miss Dolly, an English blond who gave him a furious desire to paint again. To Joyant, who sent him his brushes, paints, and canvas, Lautrec wrote on July 11, 1899, from the Hotel de l'Amirauté:

"Dear Sir [sic],

We acknowledge receipt of the painting materials. Today I did a red chalk drawing of an English girl at the Star, which I'll send tomorrow by registered mail. Please notify the administration. Ran into Guitry and Brandès. We expect to be in Granville in two days' time, and I'll keep you posted. Regards from the old chump [sic] and myself.

Yours, Toulouse-Lautrec."

Then, a few days later:

"Dear Sir,

I sent you yesterday, by registered parcel post, a panel with the head of the barmaid at the Star. Let it dry, and have it framed. Thanks for the good news on the financial front. I hope my tutor is pleased with his pupil. We leave today for Granville. Regards from Viaud and myself.

Yours, Lautrec."

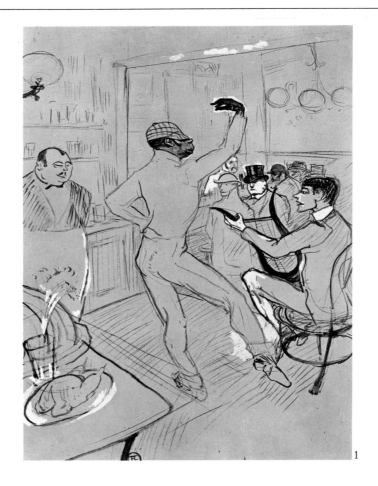

1

This vivacious portrait of Dolly he mentions here is now in the Toulouse-Lautrec Museum at Albi.

At the end of July, Lautrec sailed from Le Havre for Bordeaux and then spent several weeks with his mother nearby in the vast, peaceful Château de Malromé, in the midst of rich vineyards. After the grape harvest he returned to Paris. Then began an extraordinary spell of work, from the autumn of 1899 to the summer of 1900, which was one of the most prolific and original phases in the painter's career. His technique changed markedly: he now used a heavier impasto and darker colors, working both on wood panels and on canvas. One of his favorite models at this time was a buxom girl in a brothel, Madame Poupoule, whom he portrayed at her dressing table or standing at the foot of her bed. But above all, he delighted in portraying the girlfriend of his faithful companion Maurice Joyant, whose name was Louise; young, gay, and pretty, she worked for a dressmaker as both seamstress and model (or margouin, as it was then called in Parisian slang). Lautrec nicknamed her Croxi-Margouin (i.e., Croques-y-Margouin)—or pretty enough to eat.

Paul Leclercq, a poet often painted by Lautrec, has described his complex personality: "Lautrec loved to be with women, and the more illogical they were, the more giddy, impulsive, or foolish, the more that he liked them—provided only that they were natural, for Lautrec en-

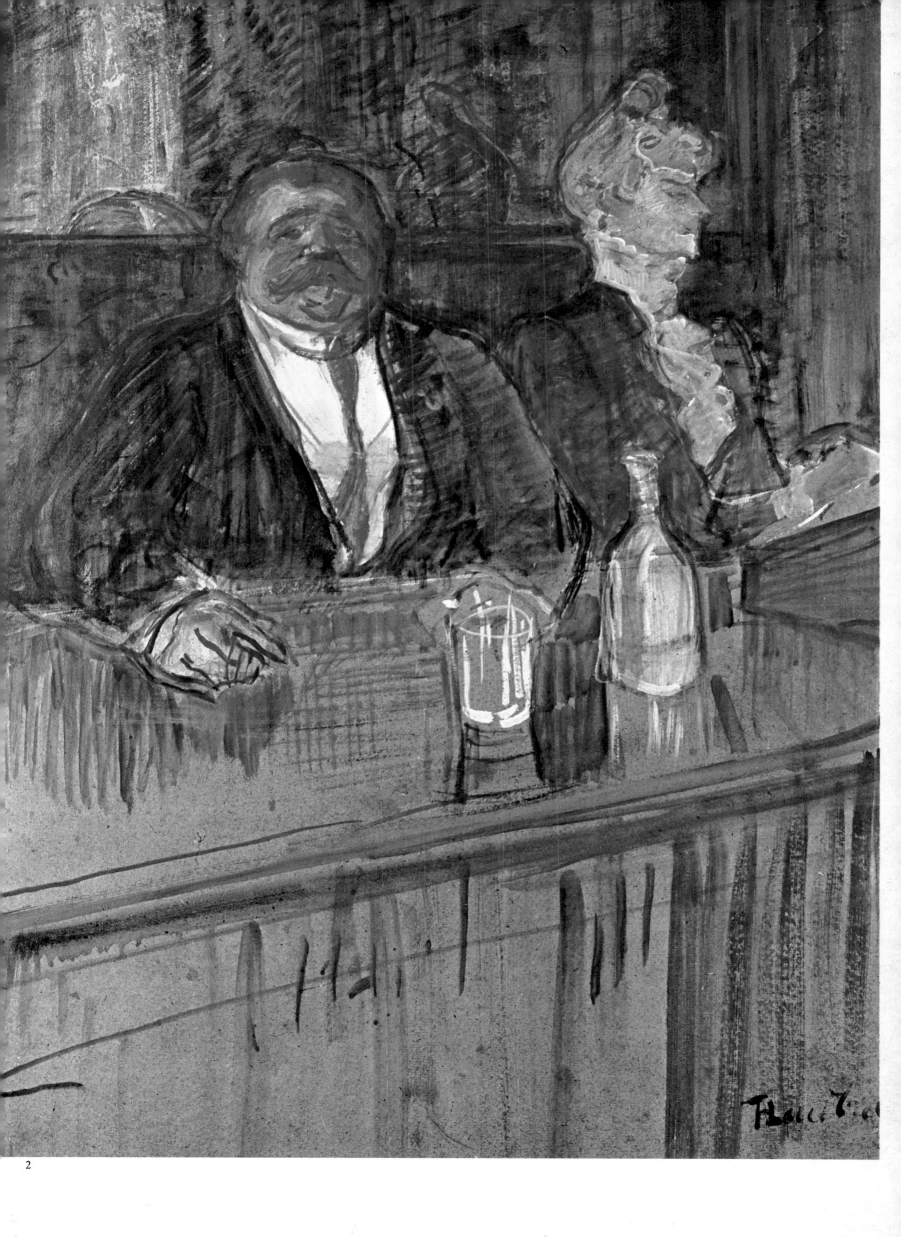

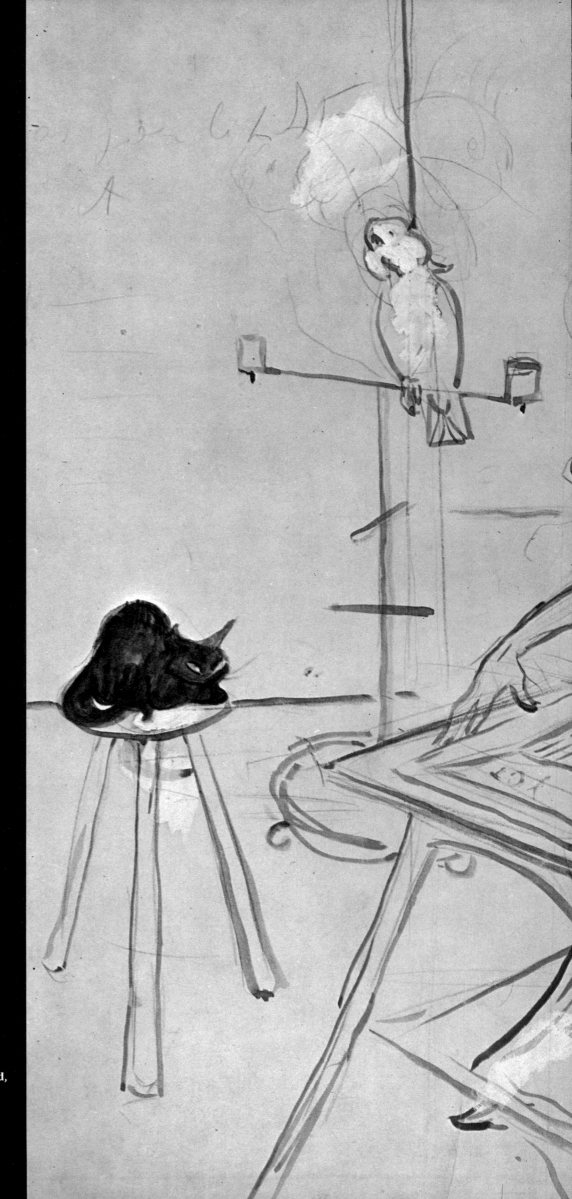

The Motograph, 1899.
Blue crayon and India ink on Bristol board,
19³/₄ × 23⁵/₈ in. Paris, Private collection.

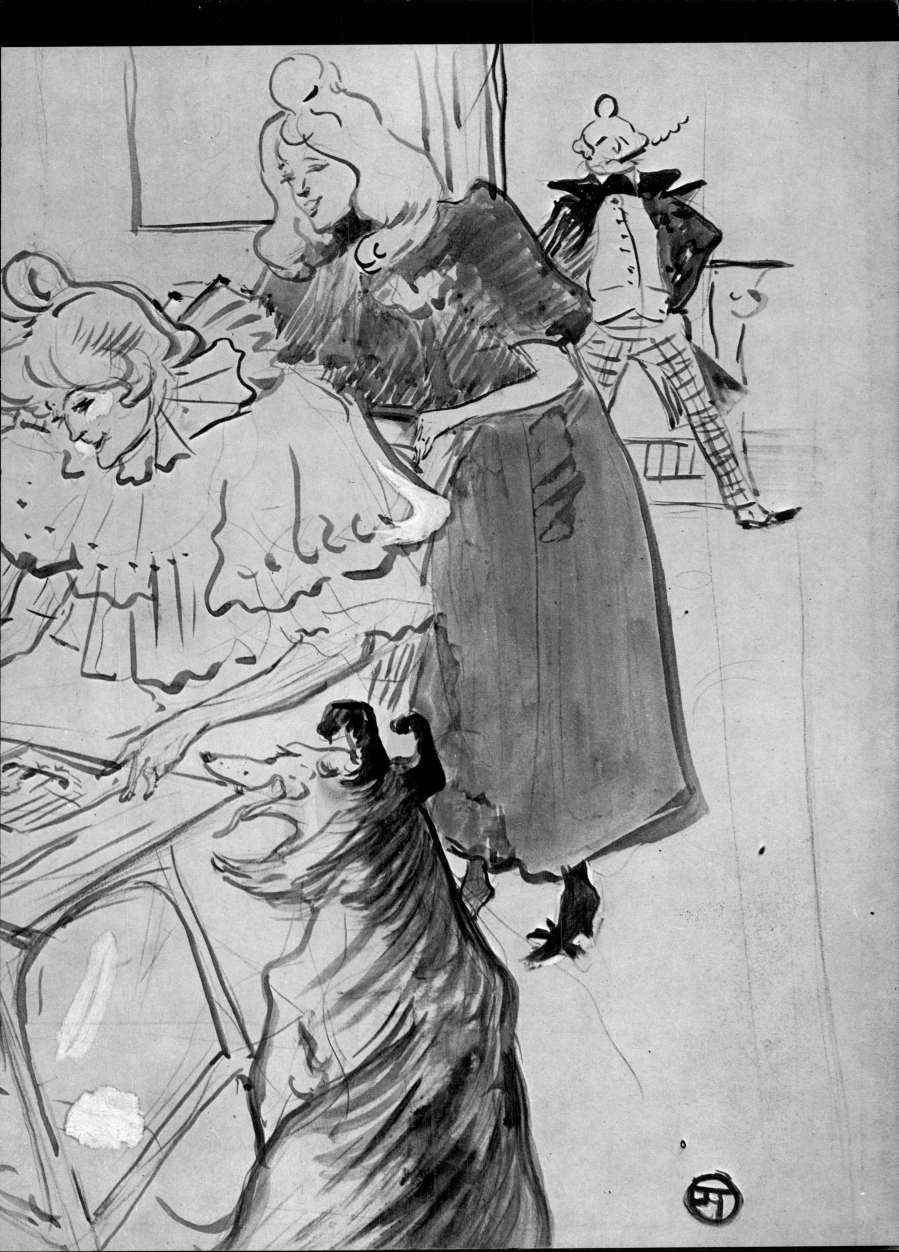

1

2

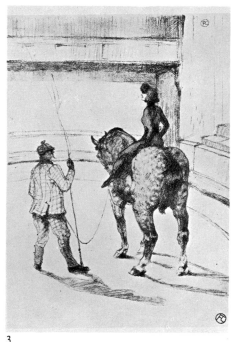

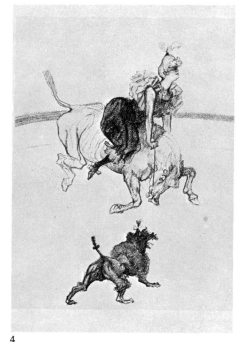

3

4

joyed drawing people out, and was interested and amused by the freshness and naïveté of these little scatterbrains. ... The passing mistress of one of his friends was for a long time one of his closest companions. This was a young modiste with sumptuous blond hair and an alert little squirrel face, whom he called Croxi-Margouin, or Margouin for short. With her, Lautrec behaved like a child with another child. They understood each other. What he felt for his women friends was a curious mixture of jovial comradeship and restrained desire. And since he was conscious of his inferiority yet, like Cyrano, knew nothing of petty jealousy, his greatest joy when he appreciated a woman but refrained from showing his true feelings was

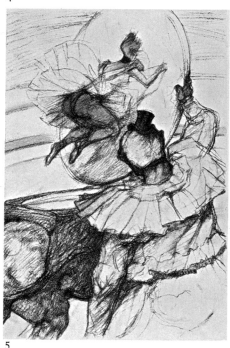

5

**1 At the Circus: Equestrienne, 1899. Crayon, $16^{1}/_{8} \times 10^{1}/_{4}$ in.
Albi, Musée Toulouse-Lautrec.**
**2 At the Circus: Trained Pony and Baboon, 1899. Crayon, $17^{1}/_{8} \times 10$ in.
Chicago, Courtesy of the Art Institute of Chicago.**
3 At the Circus: The Equestrian Rehearsal, 1899. Crayon, $14 \times 9^{7}/_{8}$ in.
**4 At the Circus: Clowness, 1899. Crayon, $14 \times 9^{7}/_{8}$ in.
Collection of Mr. Philip Hofer.**
**5 At the Circus: Equestrienne Jumping through a Hoop, 1899.
Crayon, $14 \times 9^{7}/_{8}$ in. Private collection.**

to make her even more fully appreciated by one of his friends." "His appetite for love," wrote Thadée Natanson, "was constant, but he preferred the refinements of tender preliminaries, even though impelled to remain merely a spectator. And more than once he was seen fondling ever so gently some amazed but relenting trollop."

Though often he is described as a cynical and dissolute libertine, Lautrec was by his own testimony something of an idealist where love was concerned: "You think you're talking about love? You are only talking about sex. Love is something else, not just desire for a woman, the bed, jealousy. Othello was not in love with Desdemona; he simply owned her, that's all, and was misled by a police officer." And again: "A woman's body, a beautiful woman's body, is not made for love. It's too stunning for that!"

Lautrec's image-laden language and his curious attitudes provide clues to understanding the hidden meanings and conceits of his paintings. He was not a glib person, and when he did open his mouth, he liked to mystify people with pet expressions most often unintelligible to the uninitiated. *"Ouax rababaou!"* he would solemnly exclaim, as if speaking a foreign language. This was his imitation of a friend's bad-tempered fox terrier barking, and he used this curious sound to designate undesirable visitors or anything else that was disagreeable. "They won't have any wild pigeon with olives" was an expression he applied to people he judged incapable of appreciating a true work of art. He was very fond of cooking and was continually concocting new dishes with his friends, and wild pigeon with olives was one of those tasty original recipes. Painting, for Lautrec, was like fine cuisine, something for the discerning few.

The English Barmaid at the "Star" in Le Havre, 1899.
Panel, 16¹/₈ × 12⁷/₈ in. Albi, Musée Toulouse-Lautrec.

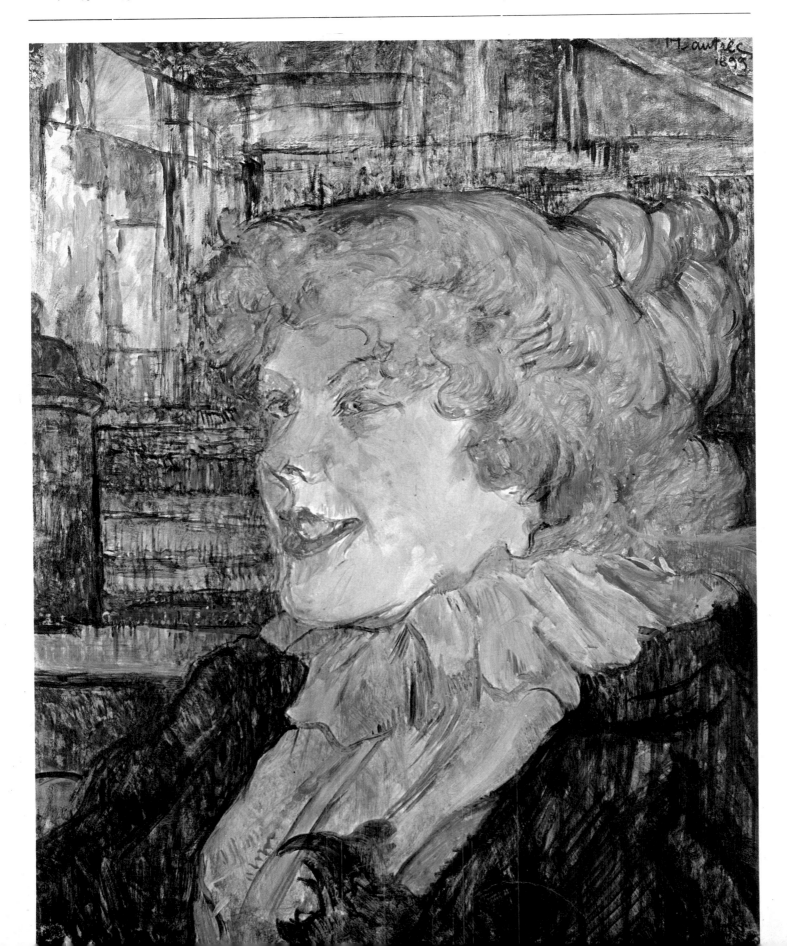

1

He called all his friends by nicknames: thus, Leclercq was "Petit Gentleman," Joyant was "Sir," and the painter Maxime Dethomas was "Grosnarbre" (because of an incorrect liaison between these two words he had once heard at the theater in M. Dethomas's presence; the latter, moreover, was tall and fat). The sculptor Carabin he called "Viande crue" (raw meat).

Two words he often used with private meanings, stressing each syllable separately, were *technique* and *côté* (side). Admiring a sharp blade, he would drawl "Tek-Nik of murder"; or ogling a charming girl, "Tek-Nik of seduction." An affected or mincing kind of feminine allure he characterized as "côté Fontanges" (referring to one of Louis XIV's elegant mistresses). "Côté roupie" (on the snotty side) denoted anything vulgar or ugly. His conversation abounded with such personal expressions. Then, too, he seldom finished a phrase, or he let his voice trail off inaudibly, leaving his listeners in suspense. Instead of speaking his mind, he generally hinted at his thoughts. His painting is full of the same unstated allusions.

One time Lautrec invited several friends to lunch, among them the painter Vuillard. The food and wine were superlative, but to his friends' surprise there was no dessert. Instead, he took them down the street to the neighboring apartment of the Dihau brothers, musicians in the Opera orchestra who were admirers, models, and collectors of Degas. There, on the walls, Lautrec showed his guests some masterpieces which are now among the glories of the Jeu de Paume, the museum of Im-

pressionism. "There is your dessert," he said. What better way of saying that for him art was one of the most natural, most necessary pleasures that life can offer to man? He is usually thought of as an artist of straightforward descriptive talents, but his true gift lies in his power of suggestion.

In 1900, despite all his precautions and care, his health showed signs of breaking down again. That spring, following a slump in wine sales, his mother decided to reduce his allowance. Lautrec was humiliated and was seriously inconvenienced, for his paintings did not sell and he had never charged for his posters and illustrations. He left for Normandy sooner than usual in that year. In Honfleur, at the request of the great actor Lucien Guitry, he decorated his last theater program. To evoke *L'Assommoir* ("The Barroom"), a play adapted from Zola's novel, he depicted around a bar his hotel-keeper Cléry, his wife Blanchette, and a sailor named Laguerre, with whom he sometimes went boating under the watchful eye of "admiral" Viaud. In late June he was in Le Havre. "Old Chump [*sic*]," he wrote to Joyant on June 30, "the Star and the other bars are carefully watched by the police, so I'm sailing this evening for Taussat on the Worms line. Yours, Henri Lautrec and Co., all very, very limited."

An idle summer on the Bay of Arcachon, nearby Bordeaux, restored Henri's strength a little, but not enough for him to return to Paris in the fall. Still tired and in low spirits, and perhaps short of money as well, he went no farther than Bordeaux, the metropolis of south-

western France. Attending the opera there, he was delighted with some of the performers and painted Mademoiselle Cocyte in Meilhac and Halévy's *La Belle Hélène* and Mademoiselle Ganne in a now-forgotten opera called *Messalina*. He wrote to his perennial confidant Joyant on December 6, 1900:

"Dear Sir,

I am working hard, and I'll soon be sending you some of my things. Where shall I address them, to Boulevard des Capucines or Rue Forest? Awaiting orders. Would you mind sending me two or three copies of the *Assommoir* theater program? Address them to me at Rue de Coudéran, Bordeaux. Here *La Belle Hélène* delights us. It is admirably

2

1 Mademoiselle Ganne as Messalina at the Bordeaux Opera, 1900.
 Drawing, 9⁷/₈ × 13³/₈ in. Private collection.

2, 3 Drawings of Greek warriors for "La Belle Hélène" by Meilhac and Halévy.

4 Messalina Seated, 1900. Canvas, 37³/₄ × 30¹/₂ in.
 Collection of Henry Pearlman, New York. (Photo Josse)

3

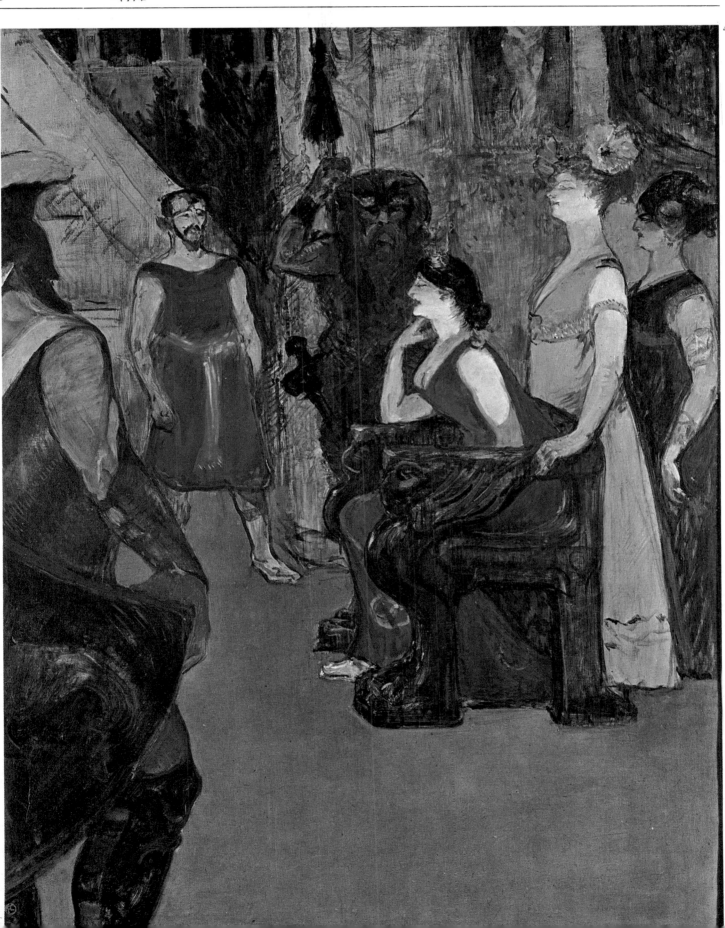

4

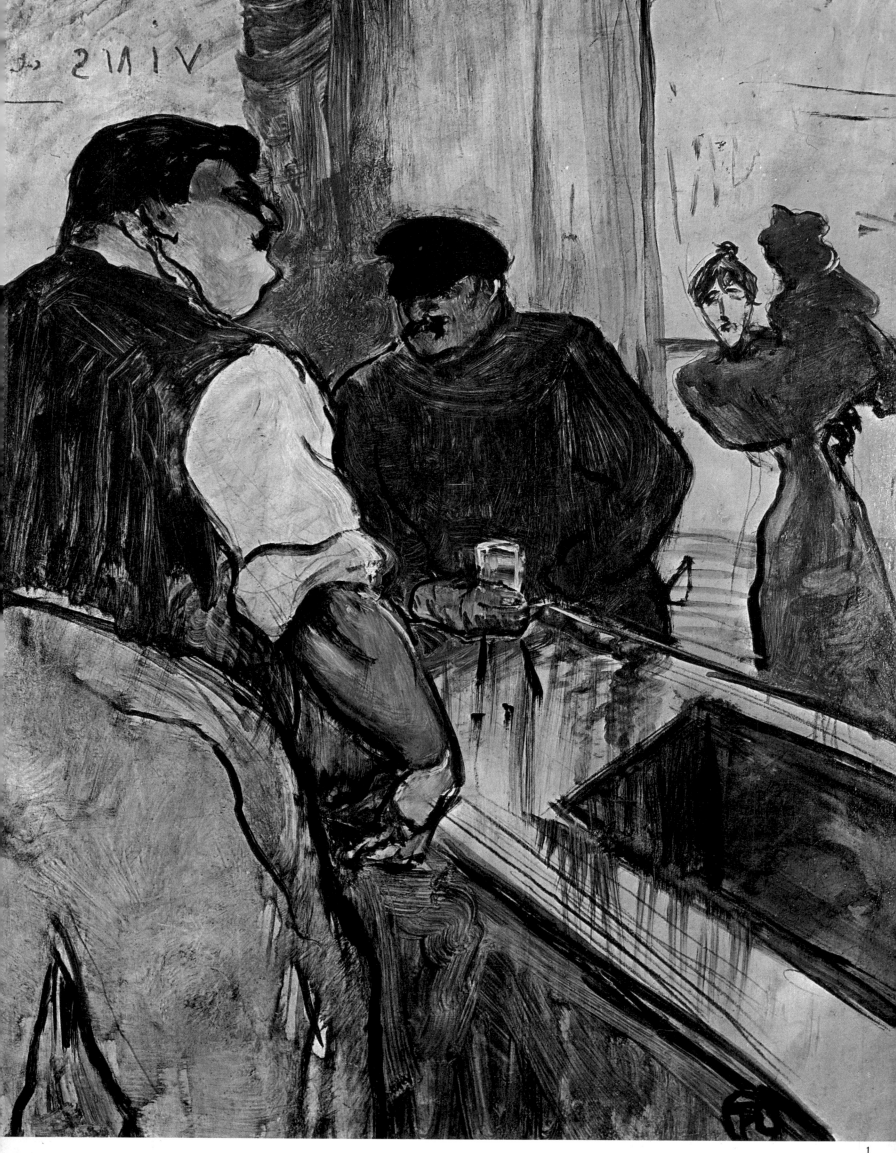

staged, and I have hit the thing off. Helen is played by a fat whore who is named Cocyte. With love from Viaud and me too.
Yours, Toulouse-Lautrec."
And a few days later:
"Dear Sir,
A merry Christmas and happy New Year. [*sic*] Send me without delay both the *Assommoir* and the *Messalina* programs and, above all, the money [*blé*] we need to keep going. I'm talking to *you*.
Yours, T.L."
In the spring of 1901 he finally thought of returning to Paris:
"Dear Sir,
I am very satisfied. [*sic*] I expect you'll be even more pleased with my new *Messalina* pictures. I have sent off Gros Narbre [the painter Dethomas] with two chameleons rolling their terrifying eyes. We had a cup of coffee together at the station, and he goes ahead like John the Baptist, the Precursor, to announce my arrival.
Yours truly [*sic*], T.L."
When Lautrec reached Paris in early May 1901, with Viaud, Joyant was alarmed by the physical change apparent in him: "It was heartbreaking to see him, after an absence of nine months, looking so thin and weak, eating practically nothing, but as lucid as ever and still full of zest at times." In the next three months he revisited well-loved old friends and former haunts, as if on a final pilgrimage. He saw La Goulue and Loïe Fuller, went to the races at Longchamp, made the rounds of the Montmartre bars and the cabarets. Joyant adds: "For years he hadn't touched anything in the storeroom of his studio, but now he wanted to look at everything again. He put his canvases and sketches in order, set his monogram on them, and signed whatever seemed worthwhile to him. He finished some paintings

that had long been left on their stretchers." He completed the portraits of several friends, Rivoire, Wurtz, and Raquin, and painted his cousin Gabriel Tapié de Céleyran taking the oral exam for his medical degree before an intimidating board of experts. "When in July 1901," wrote Joyant, "we saw Lautrec and his faithful friend Viaud off for Arcachon, none of us had any illusions; we were not at all certain of seeing each other ever again. His farewell left no doubt that he fully realized the condition he was in. When a man feels the end is near, some mysterious urge often draws him back to the places of his childhood."
In August, while staying again on the Bay of Arcachon, he had a stroke. His mother came and took him back, half-paralyzed, to the Château de Malromé, for his one desire now was to end his days near her amid the ripening vineyards on the family estate. He still tried to draw and paint sometimes, and painfully added some colors to a portrait of Viaud dressed as an admiral, a memento of their sailboat outings in Normandy, hung in his mother's dining room. And when the village priest called at their castle, Lautrec joked with him: "I would rather see you now, Father, than when you come again someday with your little bell." His strength was failing, and he was soon unable to walk. During the day he was placed in a chair in the garden, for he wished to stay outdoors as much as possible, amid nature in the fine summer weather.
About the beginning of September, Count Alphonse was called to his son's bedside. The death agony was unexpectedly long. Henri's eccentric father, though he loved his son, was ill-at-ease in a sickroom. And as he watched flies settling on his son's

2

motionless body, the Count, with a hunter's instinct, picked up an elastic band in a comic gesture, as if to attack them with a sling. The artist, though now very near death, revived momentarily and murmured in disrespect: "Will you always be so ...?" Henri de Toulouse-Lautrec died on September 9, 1901, at 2:15 A.M., at the age of thirty-six years and ten months.

DOCUMENTATION

LAUTREC
YEAR BY YEAR

1871 Galloping Horses; Cart and Horses. Drawing, 6³/₄ × 9 in.
Château du Bosc, Tapié de Céleyran Collection.

1872 Break Drawn by Two Horses. Watercolor.
Albi, Musée Toulouse-Lautrec.

1873 Mare and Foal. Drawing, 7 × 9¹/₈ in.

1874 Deer. Drawing, 6¹/₈ × 8 in. Private collection.

1875 Horses and Riders. Watercolor, 9 × 5¹/₂ in.
Albi, Musée Toulouse-Lautrec.

1876 Birds. Pen, pencil, and red chalk drawing, 5⁷/₈×8⁵/₈ in.
Paris, Private collection.

1877 Dead Hare. Watercolor, 3¹/₂ × 5⁵/₈ in.
Paris, Private collection.

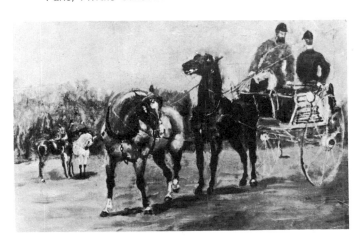

1878 Tandem. Oil on reinforced cardboard, 9⁷/ₑ × 12⁵/₈ in.
Private collection.

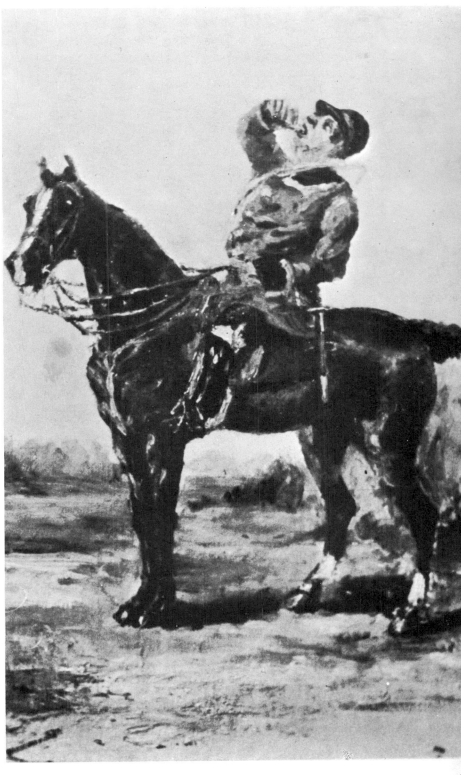

1879 Huntsman in the Field. Oil on reinforced cardboard,
13³/₄ × 9⁷/₈ in. Private collection.

1882 Oxen with Cart. Oil on cardboard, $10^7/_8 \times 15$ in.
Paris, Private collection.

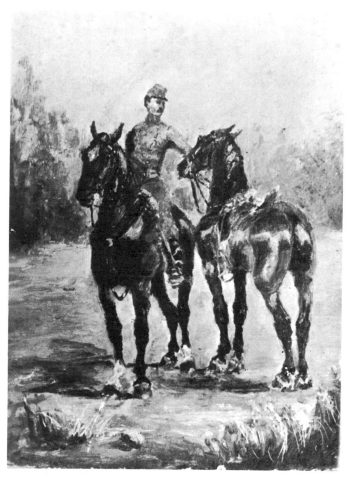

1880 Two Horses with Orderly. Oil on cardboard, $12^3/_4 \times 9^3/_8$ in.
Albi, Musée Toulouse-Lautrec.

1883 Ploughing in the Vineyard. Canvas, $22 \times 18^1/_8$ in.
Dallas, Collection of Algur H. Meadows.

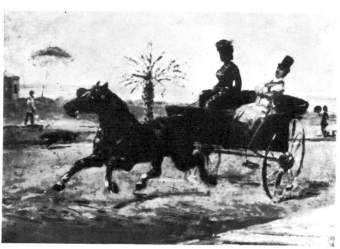

1881 "La Comtesse Noire." Panel, $12^1/_4 \times 15$ in.
Cambridge (Mass.), Courtesy of The Fogg Art Museum,
Harvard University, Bequest of Maurice Wertheim,
Class of 1906.

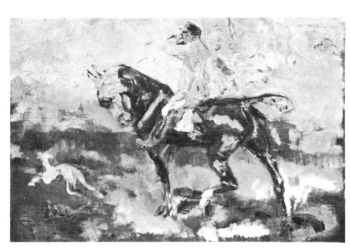

1884 Huntsman in the Field. Panel, $6^1/_2 \times 9^1/_2$ in.
Private collection.

1885 Portrait of René Grenier. Oil on cardboard, $18^1/_8 \times 11$ in.
Collection of Mr. and Mrs. Morris W. Haft.

1886 Dancers. Canvas, $17^3/_8 \times 33^7/_8$ in.
Formerly Orosdi Collection.

1887 Masked Ball at the Elysée-Montmartre. Canvas,
$22 \times 17^3/_8$ in. New York, Private collection.

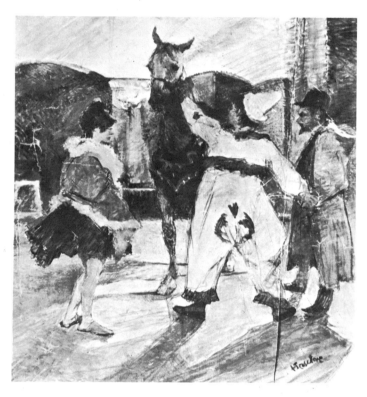

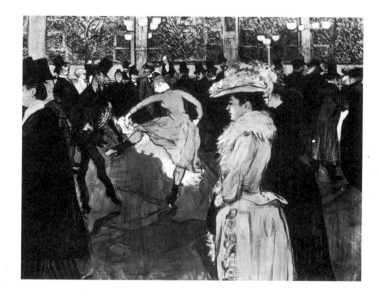

1888 At the Circus: In the Wings. Canvas, 26³/₈ × 23⁵/₈ in.
The Newark Museum of Art.

1890 Dance at the Moulin Rouge. Canvas, 45¹/₂ × 59 in.
Philadelphia, Henry P. McIlhenny Collection.

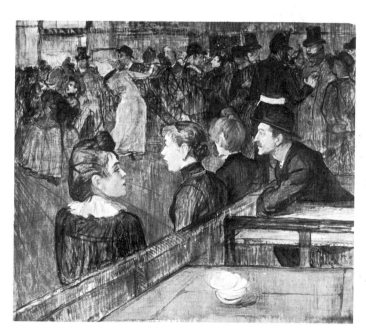

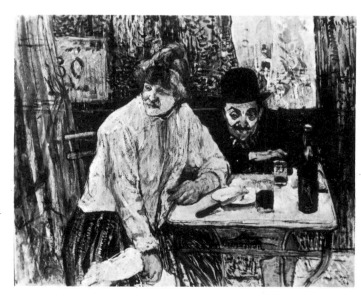

1889 At the Moulin de la Galette. Canvas, 35 × 39⁷/₈ in.
Chicago, Courtesy of The Art Institute of Chicago.

1891 At La Mie. Oil on cardboard, 21 × 26³/₄ in.
Boston, Museum of Fine Arts.

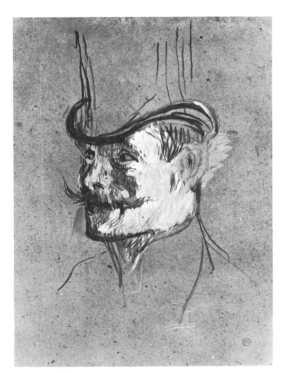

1892
The Englishman
Mr. Warner.
Oil on cardboard,
$22^1/_2 \times 17^7/_8$ in.
Albi, Musée
Toulouse-
Lautrec.

1893
The Laundryman
of Rue des
Moulins. Oil on
cardboard,
$26^3/_8 \times 17^3/_4$ in.
Albi, Musée
Toulouse-
Lautrec.

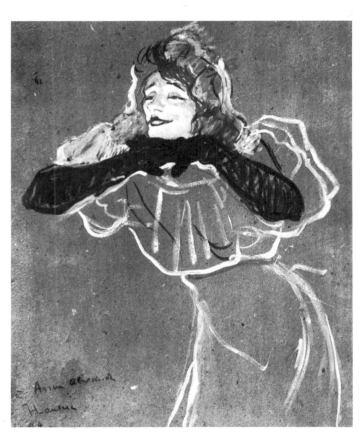

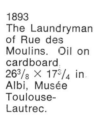

1894 Yvette Guilbert. Oil on cardboard, $22^7/_8 \times 17^3/_8$ in.
Moscow, Museum of Modern Art.

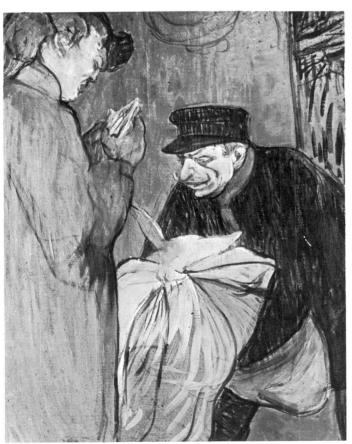

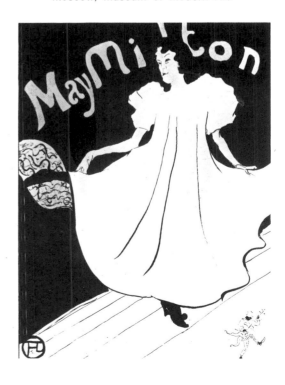

1895
May Milton.
Poster,
$31 \times 23^1/_2$ in.

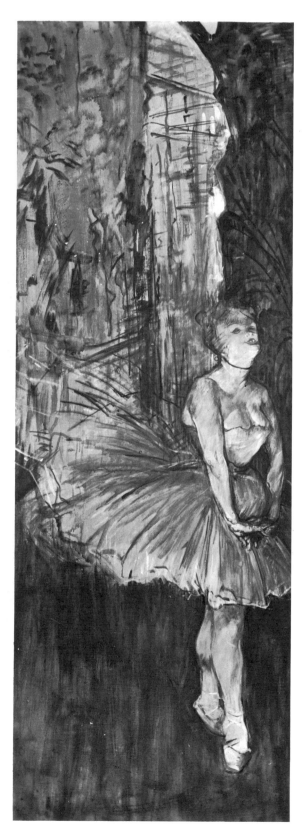

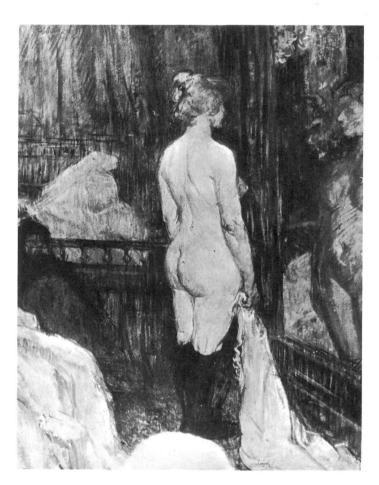

1897 Nude Woman before a Mirror. Oil on cardboard, 24⁷/₈ × 18⁷/₈ in. Collection of Mrs. Enid A. Haupt.

1896
Dancer. Canvas,
78³/₄ × 28³/₈ in.
Paris, Private
collection.

1898
Mademoiselle Ciriac.
Oil on cardboard,
25⁵/₈ × 19¹/₄ in.
Private collection.

1899 Trapeze Act without the Net. 19³/₄ × 12³/₄ in.
Cambridge (Mass.), Courtesy of The Fogg Art Museum,
Harvard University, Grenville L. Winthrop Bequest.

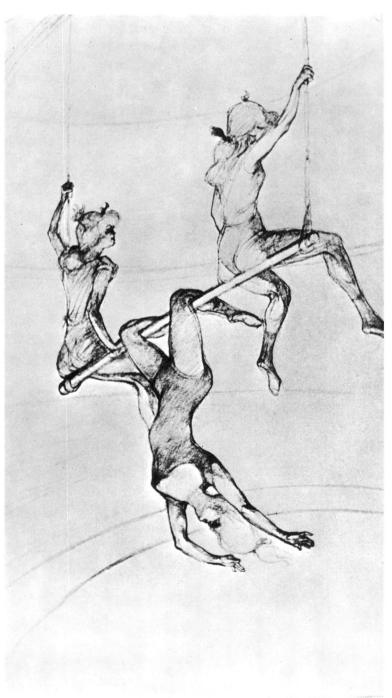

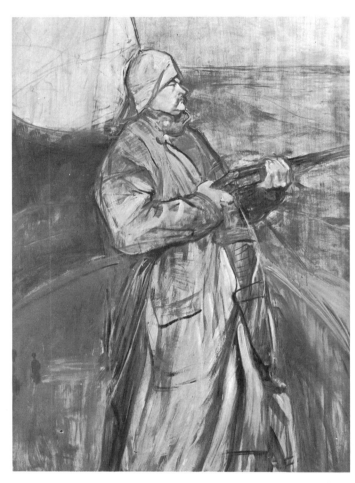

1900 Portrait of Maurice Joyant. Panel, 45⁷/₈ × 31⁷/₈ in.
Albi, Musée Toulouse-Lautrec.

1901 An Examination at the Paris Medical School.
Canvas, 25⁵/₈ × 31⁷/₈ in. Albi, Musée Toulouse-Lautrec.

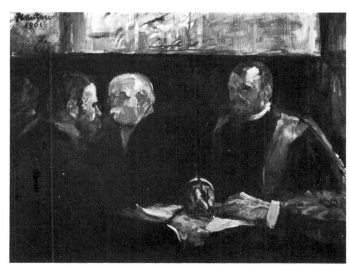

1 Woman among the Leaves, 1891. Panel, $21^5/_8 \times 18$ in. Private collection.

EXPERTISE

For several reasons, both historical and technical, Henri de Toulouse-Lautrec is not one of those painters whose works are particularly difficult to identify. In his lifetime he sold or gave his works to only a comparatively small number of relatives, friends, and clients. Thus it is quite unusual to come upon a Lautrec painting, or even drawing, whose history cannot be traced back to its presence in the artist's studio—particularly since at the time of his death most of his works were still in his studio. Maurice Joyant drew up a complete inventory of them which has proved a reliable guide. Moreover, though Lautrec's technique evolved a great deal in the course of his brief career, all his works are characterized by their extremely incisive and vivid line and by a predilection for strong expression over academic correctness. In general, then, without fear of going wrong, one can say that nothing either badly drawn or lifeless can possibly be by Lautrec's hand. It might be just as well to add, for the benefit of anyone who may hope to turn up something new, that the chances of discovering any unknown Lautrecs are very slender.

The signatures on his works vary a great deal. The paintings, drawings, and watercolors remaining in his studios after his death were stamped "TL" by his friend Maurice Joyant. The ink he used, however, was not always of good quality, and in some cases all trace of this stamp has now disappeared. The two most frequent signatures are "T-L" and "T-Lautrec," either followed by the date of execution or not. But the handwriting varies considerably and does not provide reliable evidence per se for authentication. In his youth, he signed "Henri de Toulouse-Lautrec" or "H. de T-L." Then in Bonnat's studio for a short while, about 1881, he signed "Monfa" (his full family name being Toulouse-Lautrec-Monfa). Shortly after, we find him using the signature "Treclau," an anagram of Lautrec, but he soon dropped this. From 1886 on, except for an occasional jest, he always signed his work "T-Lautrec."

2 Enlarged detail of "Woman among the Leaves."

Lautrec's œuvre falls into four fairly distinct periods. During his boyhood and adolescence he was an enthusiastic amateur painter, with a technique similar to that of his uncles and his teacher René Princeteau. He was simply more spirited and more gifted than those he imitated. His early work *In the Wheatfields* is a particularly felicitous example of this youthful, lighter style. A second phase began about 1887 under the joint influence of his new teacher Cormon, the Impressionists whose work he admired in Joyant's gallery, and his friends Van Gogh, Bernard, Gauzi, and Anquetin. He aimed at a more compact style of painting, with a more controlled and polished line and a more Rembrandt-esque coloring. Without becoming an academic, for several years he was now concerned with a "correctness" which made his pictures more searching but less free in their execution. The masterpieces of this period are perhaps the portrait of Carmen Gaudin commonly entitled *The Laundress* and the profile portrait of Hélène Vary.

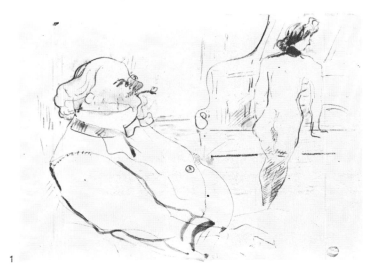

1 Brothel Scene. [Fake.]

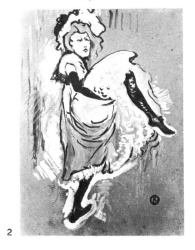

From 1890 on he consciously neglected color in favor of line and, under Raffaelli's influence, made increasing use of the neutral tone of the unprimed cardboard or canvas as an element in the design; also, in the works of this period he decidedly preferred brighter colors. His masterpieces of these years are often the paintings which seem among the least finished, such as *Woman with an Apple* or *Dancer in Back View*.

Then, from 1897, with the final phase came a return to darker, more impasted pigments and a more classical design notwithstanding his typical bold foreshortenings, as if he had come to the end of the astonishing virtuoso simplifications seen in his best posters. In Paris, Le Crotoy, Bordeaux, and at Malromé he began evolving a new style, working much less on cardboard, more on wood panels, and very often on canvas.

Needless to say, there are many fake Lautrecs. As a rule these are easily detected, for they are generally copies of his well-known posters, lithographs, and paintings. Lautrec himself never copied his own work. Pictures by his friends Belleroche, Anquetin, Gauzi, and others, though bearing a forged Lautrec signature, are readily detected as such. It was not in his temperament to be the founder of a school; he was imitated but had no personal pupils. The only problem for specialists lies in sorting out Lautrec's early works, especially the drawings, from those of his relatives and friends. In his boyhood everyone around him drew, and it seemed that everyone chose the same type of subjects. In this rather limited category of his production, then, a long familiarity is necessary to distinguish the young master's drawings from those of his artistically gifted family. Joyant's catalogue, partially, and the catalogue prepared by M. G. Dortu, more completely, provide answers to all these questions. It is worth stressing again that an "unknown" Lautrec is highly suspect and most likely to be a fake Lautrec.

2 Jane Avril, 1892–1893. Sketch. [Fake.]

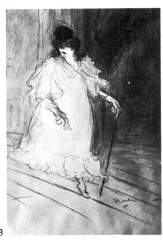

3 Cissy Loftus. [Fake.]

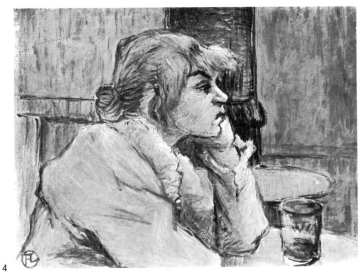

4 The Drinker. [Fake.]

LAUTREC THE JOURNALIST

Already as a child Lautrec loved to write illustrated letters and thought of keeping a diary. At sixteen, in his "Zig Zag" notebook, he wrote and illustrated an account of his trip to Nice, with the express purpose of amusing his cousin Madeleine Tapié. So it is not surprising that after his arrival in Paris he turned to journalism as much as to painting. Two friends lent him a helping hand in this pursuit: Aristide Bruant, who was on the lookout for good artists to supply illustrations for the songs he published in his magazine *Le Mirliton*, issued very irregularly; and above all, his old classmate at the Lycée Condorcet, Maurice Joyant, who acted as editor-in-chief of the magazine *Paris Illustré*, published by the Galerie Boussod-Valadon. Joyant and Lautrec saw eye to eye on one point: the visual arts were not something reserved for a dilettante elite with money enough to buy pictures. Both men considered that art was not only a matter of creation but also one of optimum diffusion. But to bring a great artist's works to all the people capable of appreciating them required suitable techniques of reproduction—expedient and yet as faithful as possible to the originals. Lautrec, often acting on Joyant's advice, not only used lithographic and woodcut techniques but also experimented with all sorts of new processes such as photogravure, color letterpress printing. Today Lautrec's paintings are often valued at several hundred thousand dollars. His illustrations instead, printed in a great many copies, are generally worth very little. Yet these costly paintings, the pride of famous museums and collectors, were often simply rough drafts for journalistic illustrations, which he ordinarily worked out with brush or pencil in hand. The catalogue of his illustrations thus forms an inventory of what the artist himself probably regarded as his most finished works, those to which he dedicated himself most wholeheartedly.

This selection is, of course, limited to works designed by Lautrec for reproduction in a newspaper or magazine, and so excludes his lithographs, paintings, or drawings which were executed as such and were only later reproduced in periodicals. We have followed a chronological arrangement. The dimensions given are those of the illustration itself, not of the block, which is often appreciably larger than the subject. The technical process employed has been noted whenever it was possible to identify it with certainty. Finally, it is important to recognize that these journalistic efforts are not original artistic creations in the fullest sense of the term—like his paintings, drawings, and watercolors—nor even more limited, quality impressions of original designs, like his lithographs and posters. They are reproductions of works intended for copying on a mass basis by a mechanical process.

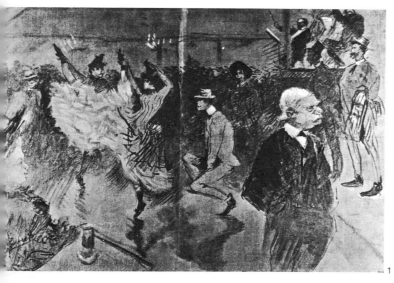

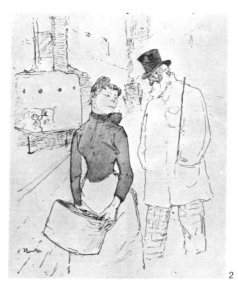

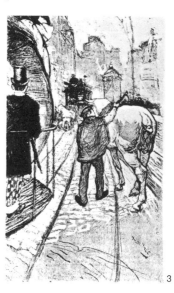

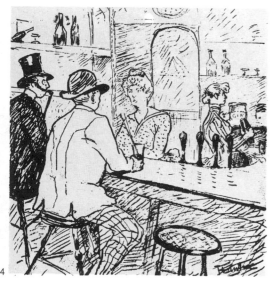

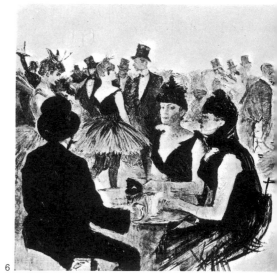

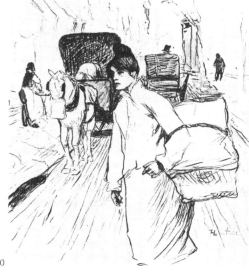

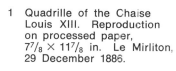

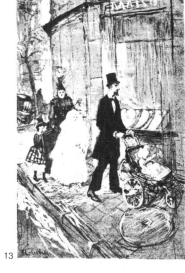

1 Quadrille of the Chaise
Louis XIII. Reproduction
on processed paper,
$7^7/_8 \times 11^7/_8$ in. Le Mirliton,
29 December 1886.

2 The Errand Girl.
Color letterpress,
$7^1/_4 \times 5^1/_2$ in. Le Mirliton,
February 1887.

3 The Trace Horse of the
Omnibus. Halftone gravure,
$7^1/_2 \times 4^3/_8$ in.
Paris Illustré, 7 July 1888.

4 Gin Cocktail. Black
letterpress, $8^5/_8 \times 7^7/_8$ in.
Le Courrier Français,
26 September 1886.

5 The Final Salute.
$8^1/_2 \times 5^7/_8$ in.
Le Mirliton, March 1887.

6 The Elysée Dance Hall.
Halftone gravure, $8^1/_4 \times 8^1/_2$ in.
Paris Illustré, 10 March 1888.

7 Riders on the Way
to Bois de Boulogne.
Halftone gravure, $6^5/_4 \times 4^3/_8$ in.
Paris Illustré, 7 July 1888.

8 The Laundress.
Halftone gravure, $6^3/_4 \times 4^3/_8$ in.
Paris Illustré, 7 July 1888.

9 Gala Evenings.
Color letterpress,
$14 \times 20^1/_8$ in.
Echo de Paris,
25 December 1892.

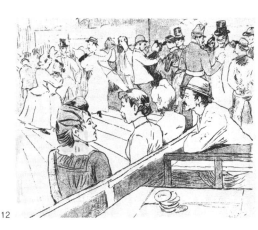

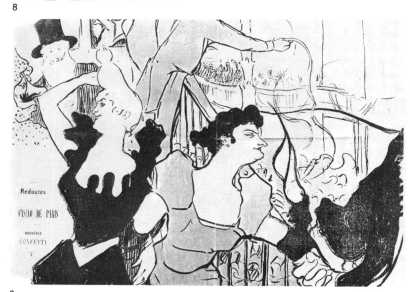

10 Outer Boulevard.
Halftone gravure, $13^3/_8 \times 9$ in.
Le Courrier Français,
2 June 1889.

11 The Drinker.
Halftone gravure, $8^3/_8 \times 8^7/_8$ in.
Le Courrier Français,
21 April 1889.

12 Le Moulin de la Galette.
Halftone gravure, $7^7/_8 \times 9^1/_2$ in.
Le Courrier Français,
19 May 1889.

13 First Communion Day.
Halftone gravure,
$6^3/_4 \times 4^3/_8$ in.
Paris Illustré, 7 July 1888.

14 The Last Drop.
Color letterpress,
$7^1/_4 \times 5^1/_2$ in.
Le Mirliton, January 1887.

15

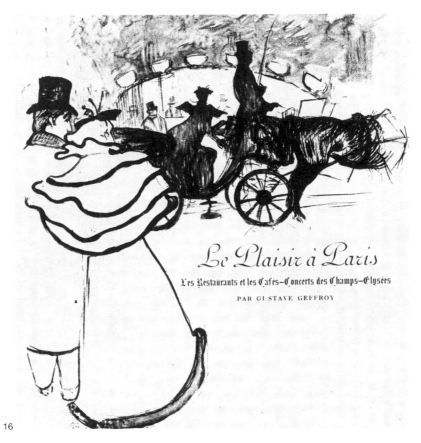

16

17

18

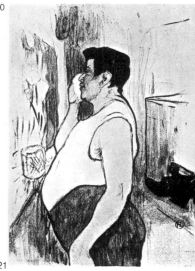

19

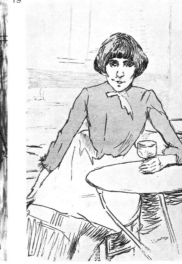

20

21

15 H. G. Ibels.
La Plume,
15 January 1893.

16 At Les Ambassadeurs.
Multicolor gravure,
$10^1/_4 \times 8^7/_8$ in.
Le Figaro Illustré, July 1893.

17 Yvette Guilbert.
Multicolor gravure,
$6 \times 3^1/_2$ in.
Le Figaro Illustré, July 1893.

18 Yvette Guilbert with
Her Left Arm Upraised.
Multicolor gravure,
$4^1/_2 \times 1^3/_4$ in.
Le Figaro Illustré, July 1893.

19 Dancer Whirling.
Multicolor gravure,
$7^1/_2 \times 5^3/_4$ in.
Le Figaro Illustré, July 1893.

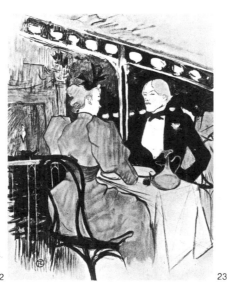

22

23

24

20 At the Bastille.
Halftone gravure,
$13 \times 9^1/_4$ in.
Le Courrier Français,
12 May 1889.

21 Caudieux.
Multicolor gravure,
$4^1/_2 \times 3^1/_8$ in.
Le Figaro Illustré, July 1893.

22 Jane Avril.
Halftone gravure,
$3^3/_8 \times 2^3/_4$ in.
L'Art Français, 29 July 1893.

23 Smart Set.
Multicolor gravure,
$7^5/_8 \times 5^7/_8$ in.
Le Figaro Illustré, July 1893.

24 Prairice.
Multicolor gravure,
$4^7/_8 \times 2^5/_8$ in.
Le Figaro Illustré, July 1893.

25 La Macarona as a Jockey.
Monochrome gravure,
$5^1/_4 \times 5^1/_2$ in.
Le Figaro Illustré,
February 1894.

26 The Flower Girl.
Monochrome gravure,
$2^3/_8 \times 2^3/_4$ in.
Le Figaro Illustré,
February 1894.

27 Judic.
Halftone gravure,
$5^1/_2 \times 4^1/_2$ in.
L'Echo de Paris,
9 December 1893.

28 At the Opera Ball.
Monochrome gravure,
$15^1/_2 \times 8^1/_4$ in.
Le Figaro Illustré,
February 1894.

29 At the Moulin Rouge.
Multicolor gravure,
$10^1/_2 \times 8$ in.
Le Figaro Illustré,
February 1894.

30 Women in a Bar.
Monochrome gravure,
$6 \times 4^1/_2$ in.
Le Figaro Illustré,
February 1894.

31 Two Women Waltzing.
Monochrome gravure,
$5^5/_8 \times 2^7/_8$ in.
Le Figaro Illustré,
February 1894.

25

26

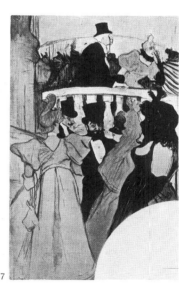

27

28

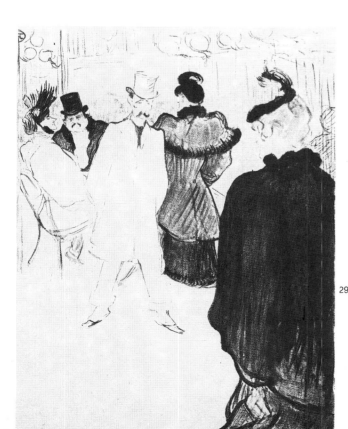

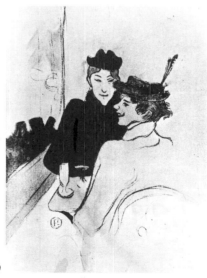

29

30

31

32

33

34

35

36

37

38

39

40

32 Dream of Lost Illusions!
 Letterpress, $1^3/_8 \times 2$ in.
 La Revue Blanche,
 June 1894.

33 A Spanish House.
 Halftone gravure,
 $1^3/_8 \times 2^1/_8$ in.
 La Revue Blanche,
 June 1894.

34 Death of the Pig.
 Letterpress, $1^3/_4 \times 2^1/_8$ in.
 La Revue Blanche,
 June 1894.

35 The Spider Dropped
 from the Ceiling.
 Letterpress, $1^3/_8 \times 2$ in.
 La Revue Blanche,
 June 1894.

36 Bathing.
 Halftone gravure,
 $2^3/_4 \times 1^3/_4$ in.
 La Revue Blanche,
 June 1894.

37 The Master's Milk.
 Letterpress.
 La Revue Blanche,
 June 1894.

38 Young Asiatic.
 Letterpress, $2^1/_8 \times 1^1/_4$ in.
 La Revue Blanche,
 June 1894.

39 The Painter Meissonier.
 Letterpress, $2 \times 2^1/_8$ in.
 La Revue Blanche,
 June 1894.

41

ERRATUM

42

44

43

45

46

47

40 Rough Handling.
 Halftone gravure,
 $1^5/_8 \times 2^3/_4$ in.
 June 1894.

41 The Horsewoman of Barias.
 Letterpress, $2^1/_2 \times 1^5/_8$ in.
 La Revue Blanche,
 June 1894.

42 With the Girls.
 Halftone gravure, $2^5/_8 \times 1^3/_4$ in.
 La Revue Blanche,
 June 1894.

43 Under the Cold North Wind.
 Letterpress, $1^3/_4 \times 2^7/_8$ in.
 La Revue Blanche,
 June 1894.

44 Brown-Picard Method.
 Halftone gravure, $1^1/_4 \times 1^1/_4$ in.
 La Revue Blanche,
 June 1894.

45 Caricature
 of Lamartine.
 Letterpress, $2^5/_8 \times 2$ in.
 La Revue Blanche,
 June 1894.

46 Au Tartare.
 Halftone gravure, $1^3/_4 \times 2^3/_4$ in.
 La Revue Blanche,
 June 1894.

47 Woman.
 Halftone gravure, $2^3/_4 \times 2^3/_8$ in.
 La Revue Blanche,
 June 1894.

48 Footit as a Dancing Girl.
 Halftone gravure, $6^3/_8 \times 4^3/_4$ in.
 Le Rire, 26 January 1895.

49 Footit with Derby Hat.
 Halftone gravure, $2^5/_8 \times 3^1/_4$ in.
 Le Rire, 26 January 1895.

50 Head of a Negro.
 Halftone gravure, $3 \times 2^1/_4$ in.
 Le Rire, 26 January 1895.

51 Maurice Guibert.
 Bookplate, c. 1894.

52 Putting His Foot in It.
 Black letterpress,
 $2^3/_8 \times 2$ in.
 La Revue Blanche,
 15 January 1895.

53 Footit from Behind.
 Halftone gravure, $3 \times 2^7/_8$ in.
 Le Rire, 26 January 1895.

54 Yvette Guilbert.
 Color gravure, $9^1/_4 \times 6^1/_2$ in.
 Le Rire, 22 December 1894.

55 Footit as a Clown.
 Halftone gravure,
 $7^1/_8 \times 4^7/_8$ in.
 Le Rire, 26 January 1895.

48

49

50

51

52

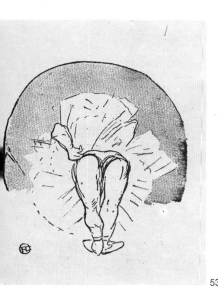

53

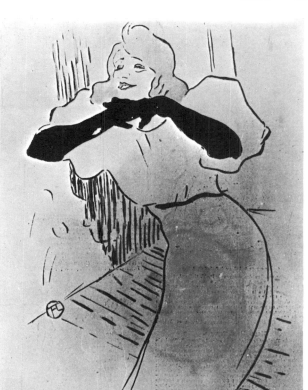

54

55

56 Elephant.
Letterpress, $7/8 \times 1$ inch.
La Revue Blanche,
15 December 1895.

56

57 At Achille's Bar.
Multicolor gravure, $6^{1}/4 \times 4$ in.
Le Figaro Illustré, July 1895.

58 At Achille's Bar.
Multicolor gravure, $4 \times 5^{1}/8$ in.
Le Figaro Illustré, July 1895.

57

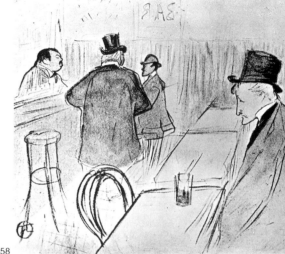
58

59

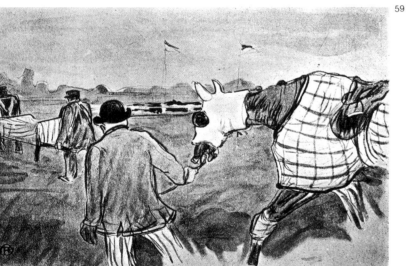

60

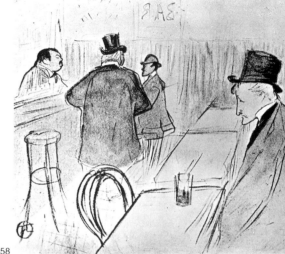
61

59 Illustration No. 4
("The Good Jockey").
Multicolor gravure, $4^{1}/2 \times 7^{1}/8$ in.
Le Figaro Illustré, July 1895.

60 Eloi the Fox.
Letterpress, 1×1 in.
La Revue Blanche,
15 March 1895.

61 Illustration No. 3
("The Good Jockey").
Multicolor gravure, $4 \times 6^{1}/4$ in.
Le Figaro Illustré, July 1895.

62 Oscar Wilde.
Letterpress, $6^{1}/4 \times 2^{3}/4$ in.
La Revue Blanche,
15 May 1895.

63 Mlle. Polaire.
Color gravure, $10^{1}/4 \times 5^{1}/8$ in.
Le Rire, 23 February 1895.

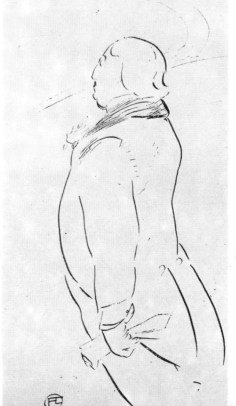
62

63

64 Beauty in Her Bed.
Multicolor gravure, $4^3/_4 \times 4$ in.
Le Figaro Illustré,
September 1895.

65 "Skating Professional Beauty."
Multicolor gravure, $8^3/_4 \times 8^1/_4$ in.
Le Rire, 11 January 1896.

64

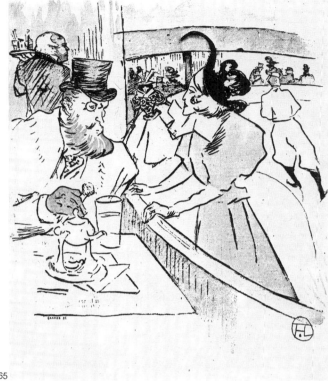

65

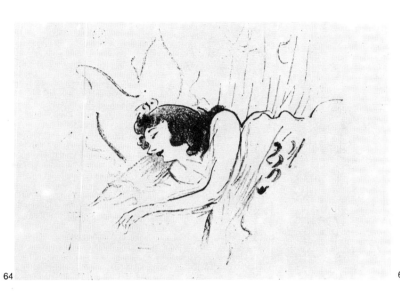

66 67 68 69

66 Beauty Refuses Her Hand.
Multicolor gravure, $6^7/_8 \times 4^3/_4$ in.
Le Figaro Illustré,
September 1895.

67 The Opera Concerts.
Multicolor gravure, $10 \times 7^7/_8$ in.
Le Rire, 8 February 1896.

68 The Marco Brothers.
Multicolor gravure, $9^1/_4 \times 8$ in.
Le Rire, 21 December 1895.

69 May Milton.
Halftone gravure, $9^1/_2 \times 7^5/_8$ in.
Le Rire, 3 August 1895.

70 Rajah's Procession.
Multicolor gravure, $7^1/_2 \times 5^7/_8$ in.
Le Figaro Illustré,
September 1895.

71 Bézique.
Multicolor gravure, $4^3/_4 \times 4$ in.
Le Figaro Illustré,
September 1895.

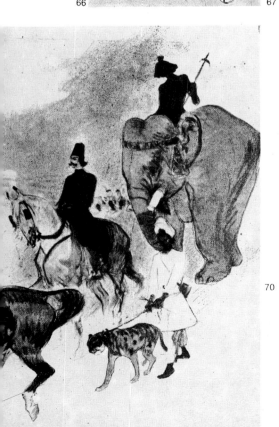

70

71

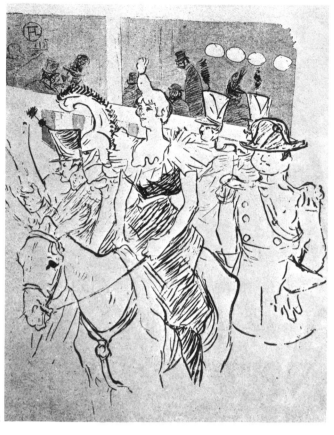

72

72 Entrance of Cha-U-Kao
at the Moulin Rouge.
Letterpress, 9¹/₄ × 8 in.
Le Rire, 15 February 1896.

73 Bust of Two Sisters.
Multicolor gravure, 3⁷/₈ × 4 in.
Le Figaro Illustré,
May 1896.

74 Girl Crying Pursued
by an Old Woman.
Muticolor gravure, 7¹/₈ × 6¹/₄ in.
Le Figaro Illustré,
May 1896.

75 The Toad.
Multicolor gravure, 4¹/₈ × 5¹/₂ in.
Le Figaro Illustré,
May 1896.

76 Getting Up. ("What Shall
We Have for Breakfast?")
Multicolor gravure, 10 × 7¹/₂ in.
Le Rire, 24 October 1896.

77 Chocolat Dancing in a Bar.
Multicolor gravure, 9¹/₂ × 8¹/₈ in.
Le Rire, 28 March 1896.

78 Old Woman Carrying
a Faggot.
Multicolor gravure, 6³/₄ × 7¹/₂ in.
Le Figaro Illustré, May 1896.

79 Mrs. Lona Barrison
with Her Manager.
Multicolor gravure, 10⁷/₈ × 8¹/₄ in.
Le Rire, 13 June 1896.

80 Henry Somm.
Les Hommes
d'Aujourd'hui, 1897 .

81 The Motograph.
Book cover, 1899.

82 Cover for "L'Image":
Marthe Mellot.
Color woodcut, 11⁵/₈ × 8¹/₂ in.
11 October 1897.

73

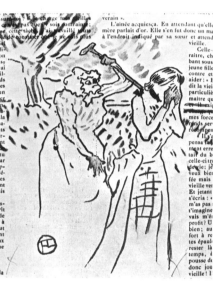

74

78

75

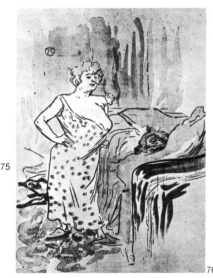

76

77

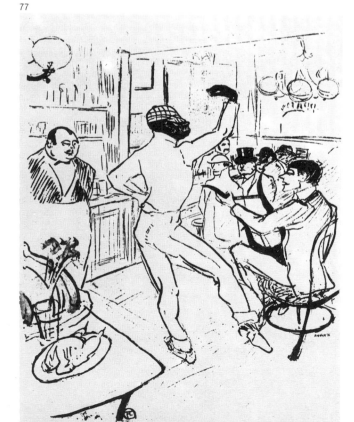

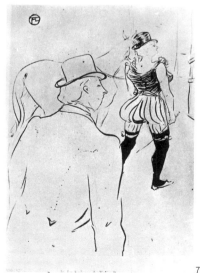

79

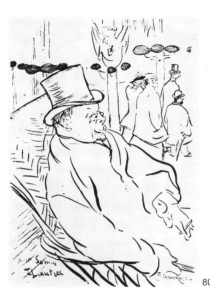

80

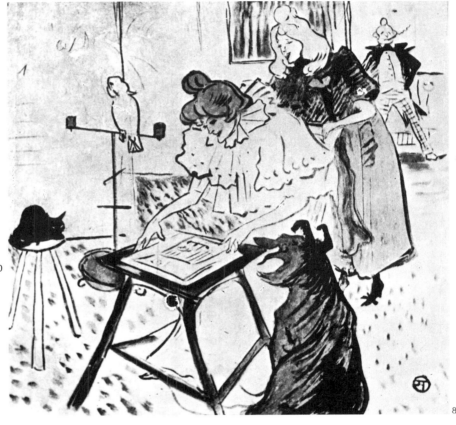

81

82

83 Snobbery, or Chez Larue.
Multicolor gravure, $7^7/_8 \times 8$ in.
Le Rire, 24 April 1897.

84 "Alors vous êtes sage?"
Multicolor gravure, $9^1/_2 \times 7^3/_4$ in.
Le Rire, 9 January 1897.

85 Mr. Baron in
"Les Charbonniers."
$10^3/_8 \times 7^5/_8$ in.
Le Rire, 30 January 1897.

86 The Barroom.
$6^5/_8 \times 4^3/_8$ in.
October 1900.

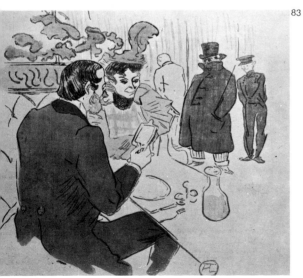

83

84

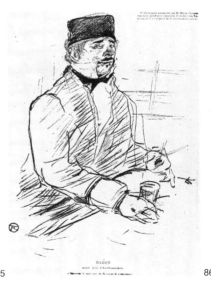

85

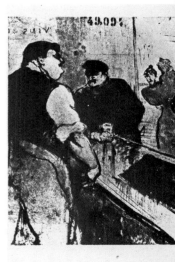

86

87 Student Ball
in Bordeaux.
December 1900.

87

BOOKS ABOUT LAUTREC

Biography and Monographs:

The best, most comprehensive account of Lautrec's life and work is *Henri de Toulouse-Lautrec* (2 vols., Paris, 1926-1927) by Maurice Joyant, the artist's schoolmate from the age of eight and his lifelong friend, publisher, dealer, and executor of his will, as well as founder of the Musée Toulouse-Lautrec in Albi. This is the fundamental work on which any study of Lautrec must be based; it contains a biography, the first *catalogue raisonné* of his paintings and drawings, and an extensive bibliography up to that time. Other contemporary accounts of great interest are Paul Leclercq, *Autour de Toulouse-Lautrec* (Paris, 1920), a perceptive and lively book; and Francis Jourdain, *Toulouse-Lautrec* (Paris, 1952), which contains a very interesting study by Jean Adhémar and is copiously illustrated. The books by Gustave Coquiot, *Toulouse-Lautrec* (Paris, 1914), François Gauzi, *Lautrec et son temps* (Paris, 1954), and Mary Tapié de Céleyran, *Notre oncle Lautrec* (Geneva, 1956), should be used with some degree of caution. Thadée Natanson published an engrossing book of anecdotes and reflections, *Un Henri de Toulouse-Lautrec* (Geneva, 1956). Also to be consulted are articles by André Rivoire in *Revue de l'Art* (December 1901, April 1902); Arsène Alexandre in *Figaro Illustré* (April 1902); and Gustave Geffroy in *Gazette des Beaux-Arts* (August 1914); as well as the special issue of *L'Amour de l'Art* (April 1931), with personal recollections by Tristan Bernard, Edouard Vuillard, and others. Also of great interest is the volume *Unpublished Correspondence of Henri de Toulouse-Lautrec*, edited by Lucien Goldschmidt and Herbert Schimmel (New York-London, 1969).

Unpublished biographical documents and, we hope, an objective synthesis of sources will be found in Philippe Huisman and M. G. Dortu, *Lautrec by Lautrec* (New York-London, 1964), which also contains a catalogue of the artist's graphic work. Additional biographies are those of Gerstle Mack, *Toulouse-Lautrec* (New York, 1938); Henri Perruchot, *La Vie de Toulouse-Lautrec* (Paris, 1958); and J. Bouret, *Toulouse-Lautrec* (Paris, 1963).

Oeuvre:

Lautrec's lithographs have been catalogued in Loys Delteil, *Le Peintre-Graveur illustré*, Vols. X-XI, "Toulouse-Lautrec" (Paris, 1920). An attempt to supplement this essential catalogue has been made in the authors' present contribution and in Jean Adhémar, *Toulouse-Lautrec: Oeuvre lithographique* (Paris, 1965).

For the posters, see E. A. Julien, *Les Affiches de Toulouse-Lautrec* (Monte Carlo, 1950, 1968); and Merete Bodelsen, *Toulouse-Lautrec's Posters* (Copenhagen, 1964). Of the many publications with numerous reproductions of Lautrec's work, we would cite as among the best those of Jacques Lassaigne, *Toulouse-Lautrec* (Paris, 1939) and *Lautrec* (Geneva-London-New York, 1953); Douglas Cooper, *Toulouse-Lautrec* (New York–London, 1955); Renata Negri, *Toulouse-Lautrec*, in "Masters of Color" Series (Milan–New York, 1966); and Fritz Novotny, *Toulouse-Lautrec* (Nev York–London, 1969).

EUROPE

AUSTRIA
VIENNA – Graphische Sammlung
Albertina
CZECHOSLOVAKIA
PRAGUE – Narodni Gallery
DENMARK
COPENHAGEN – Ny Carlsberg Glyptotek;
Statens Museum for Kunst
FRANCE
ALBI – Musée Toulouse-Lautrec
AVIGNON – Musée Calvet
BORDEAUX – Musée des Beaux-Arts
NANCY – Musée Lorrain
PARIS – Musée du Louvre; Petit-Palais;
Bibliothèque Nationale
TOULOUSE – Musée des Augustins
GERMANY
BREMEN – Kunsthalle
DRESDEN – Gemäldegalerie
HAMBURG – Kunsthalle
MUNICH – Neue Pinakothek
GREAT BRITAIN
BIRMINGHAM – Barber Institute of
Fine Arts, University of Birmingham
LONDON – Tate Gallery; Courtauld
Institute Galleries
NETHERLANDS
AMSTERDAM – Stedelijk Museum
OTTERLO – Rijksmuseum Kröller-
Müller Stichting
ROTTERDAM – Museum Boymans-
van Beuningen
SWEDEN
STOCKHOLM – Nationalmuseum
SWITZERLAND
WINTERTHUR – Collection Oskar
Reinhart am Römerholz
ZURICH – Kunsthaus
U.S.S.R.
LENINGRAD – The Hermitage
MOSCOW – Pushkin Museum
YUGOSLAVIA
BELGRADE – Narodni Gallery

LAUTREC IN MUSEUMS

NORTH & SOUTH AMERICA

BRAZIL
SÃO PAULO – Museu de Arte
U.S.A.
BOSTON – Museum of Fine Arts
BUFFALO – Albright-Knox Art Gallery
CAMBRIDGE (Mass.) – Fogg Art Museum,
Harvard University
CHICAGO – The Art Institute of Chicago
CLEVELAND – The Cleveland Museum
of Art
COLUMBUS – The Columbus Gallery
of Fine Arts
HARTFORD (Conn.) – Wadsworth Atheneum
LOS ANGELES – Los Angeles County
Museum of Art
MINNEAPOLIS – The Minneapolis
Institute of Art
NEW YORK – The Metropolitan Museum
of Art; The Museum of Modern Art;
The Brooklyn Museum
OBERLIN (Ohio) – Allen Memorial Art
Museum
PHILADELPHIA – The Philadelphia
Museum of Art
PROVIDENCE – Museum of Art, Rhode
Island School of Design
TOLEDO – The Toledo Museum of Art
WASHINGTON, D.C. – The National Gallery
of Art
WILLIAMSTOWN (Mass.) – The Sterling
and Francine Clark Art Institute